IMAGES
of *America*

PARKER

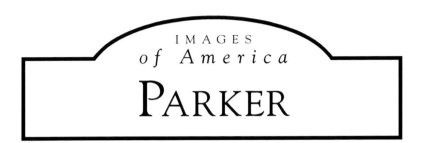

IMAGES
of America
PARKER

Sandra Jane Whelchel

ARCADIA
PUBLISHING

Published by Arcadia Publishing
Charleston, South Carolina

Printed in the United States of America

Library of Congress Control Number: 2014959592

For all general information, please contact Arcadia Publishing:
Telephone 843-853-2070
Fax 843-853-0044
E-mail sales@arcadiapublishing.com
For customer service and orders:
Toll-Free 1-888-313-2665

Visit us on the Internet at www.arcadiapublishing.com

To Darla, Riley, and Jackson, so you can learn about this great place where you live, and the two Andys as always for your support.

CONTENTS

ACKNOWLEDGMENTS

Anita, you have my deepest thanks for helping coordinate photographs with text and for your patience. A special thank you goes to Marilyn Parker for her willingness to share her collection of photographs. Thanks to Bob and Josie Fetters, who when I put out the call sent me a plethora of Parker information and images. Thank you to the staff of the Parker Library and Denver Public Library Western History Department for helping me find elusive information and photographs.

INTRODUCTION

The town of Parker, Colorado, is situated approximately 25 miles southeast of the state capital, Denver. It is higher than Denver's mile-high altitude of 5,280 feet above sea level at 5,900 feet. Until a population explosion after the 1980s, any comparison to Denver stopped there. The sleepy little town of the early 20th century boasted a population of less than 100, as older residents explained: 40 residents and 100 dogs. Now with a population near 47,000 people, Parker is considered a southern suburb of Denver. The town, which had four one-block streets, now encompasses 21.1 square miles.

Long before humans came to what would eventually be Parker, Colorado, the area was a huge lake. As the water receded, cells in logs under the lake were replaced by minerals, and petrified wood was formed. The wood, thought to be pine and occasionally palm, emerged as the lake dried. The petrified wood figured prominently in the attraction of Native Americans to the area 2,000 years ago. They carefully honed the shiny rock into spear points and arrowheads.

The early natives found this area ideal for wintering over, as they had a ready supply of game in the form of deer, elk, antelope, and bison. Indigenous chokecherry bushes added much-needed vitamin C to the native diet. Ample water from Cherry Creek and a type of native clay that could be used for lining woven baskets to make them waterproof was an added bonus.

When the first white men entered the area seeking gold, the more sophisticated tribes of Cheyenne, Kiowa, and Ute still remained in the area, camping along Cherry Creek in winter. Tribes led by Ute chiefs Ouray and Washington became friendly with some of the early settlers, including the Tallman family, and frequently visited them while passing their cabin on the way to the eastern plains to hunt.

When reality indicated that there was not enough gold for everyone to get rich, the prospectors who had come to mine the gold rich streams reverted to their former occupations as dairymen, ranchers, and farmers, eventually establishing the town of Parker. Dairies were founded along Cherry Creek to supply milk, butter, and cheese to the rapidly growing Denver area. Large cattle ranches sprouted up in the fertile flood plain, where the cattle could graze without a concern for winter hay.

Lumber mills provided thousands of board feet to build houses for Denver. In some places, trees were clear cut, making the pine forests a memory. Those trees too small or diseased to be used for lumber were thrown into pits, set on fire, covered with dirt, and allowed to smolder, making charcoal for the cook stoves and blacksmith fires in Denver.

Lumbering and agriculture brought the small Denver and New Orleans Railroad to Parker in the 1880s, but even with faster access to the Denver market, the area did not experience a huge growth spurt. The town had two hotels, and at one point three grocery stores, but as travel times to the metropolis of Denver decreased so did the population of Parker and its businesses.

The railway first known as the Denver and New Orleans Railroad was established and financed by Gov. John Evans, but it failed to prosper taking freight and passengers between Parker and

Denver or Colorado Springs. To insure that the tracks would come directly through town instead of passing along Cherry Creek, James Sample Parker sold the right-of-way to the company for $1. George Parker sold his right-of-way through town, and the station became Parker's. A section house, hand-dug well, pump house, and water tower were added to the stop. Later, storage sheds and cattle pens were provided.

The name of the line changed from the Denver and New Orleans to the Denver and Gulf and then finally to the Colorado and Southern. These changes did not help the line's financial standing. The Parker station was closed in 1931, and when a flood washed out a large portion of the track in 1935, the line was closed and the track pulled up.

Children in the area first attended the Fonder School, about 10 miles from town. When James Sample Parker's daughter Edith was old enough for school, the Parkers did not want her to ride her horse to the Fonder School, so James built a new school across the road from the 20-Mile House. He furnished it with desks, books, and all necessary supplies. He paid the teacher's salary for the year and allowed her to board at the 20-Mile House for free.

James Sample Parker continued to contribute to the growth of the area throughout his years living there. When his wife died in 1887, he donated a piece of land to establish a cemetery. He sold the 20-mile property in 1910 and moved to Denver. He died later that year.

With the solid foundation launched by the Parker brothers, the town grew to encompass approximately two blocks square. Ruth Chapel, a community church, was built with local manpower and finished in 1913. Two years later, Ave Maria Catholic Church joined Ruth Chapel.

In 1915, the Parker Consolidated School pulled students from the Parker, Plainfield, and Allison Schools into one building. Students were transported by horse-drawn bus. The building's first floor housed the grade school with upstairs rooms reserved for high school students. Over 30 years later, two other one-room school districts, Rattlesnake and Hilltop, were incorporated into the Parker district. In the late 1940s, a bond issue, which would have built a gymnasium for the Parker students, was defeated in a county-wide election. Once again, the residents of the area pulled together to construct a community building, which added not only a gymnasium, but also a stage for plays and band productions and a lunchroom to provide hot lunches for the students. Completed in 1950, the students enjoyed the building for only eight years. In 1958, the Douglas County School District consolidated the high school, and students were bussed 27 miles to the Douglas County High School. A local high school did not return to the area until 1983, when Ponderosa High School was built. Now the Parker area hosts five high schools, two junior high schools, and 12 elementary schools.

The 1970s brought more heartbreak to the town when a real estate development company arrived with promises to revitalize Parker. Beginning at the west end of Mainstreet, the company razed buildings with no regard to historical value or importance. New Victorian-style buildings were started, but in many cases they were not finished after the company lost financing. A new firehouse was constructed; however, legal complications prevented its occupation by the fire department. Unfinished apartment buildings and businesses sat decaying for over a decade.

In the most recent 40 years, visionaries have influenced Parker. The town, incorporated in 1981, is now a center for thriving businesses, which have flourished due to Parker's proximity to Denver. The cooler temperatures, subdivisions with large lots encouraging horse ownership, and easygoing lifestyle have made Parker an ideal community.

One

BEFORE AND AFTER NATIVE AMERICANS

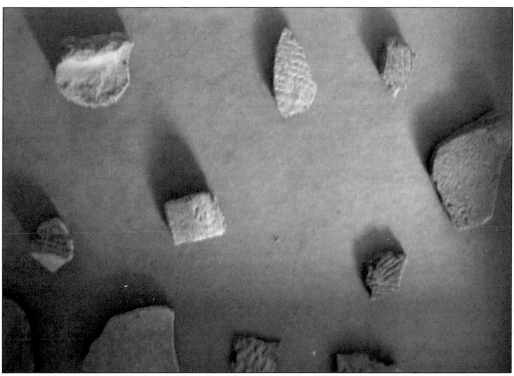

Long before the pioneers came to Colorado, bands of Native Americans roamed the Parker area. These early residents dug pit houses and used the abundant game for food. When the Reuter-Hess Reservoir was under construction, archeologists discovered communities where these early natives lived. Pottery shards and weapon chips remain as evidence of these early inhabitants. The pottery was not actually pots as one might think, but rather locally found clay, which was pressed into the inside of a woven basket to make it waterproof. The distinctive woven pattern is indicative of this method. (Author's collection.)

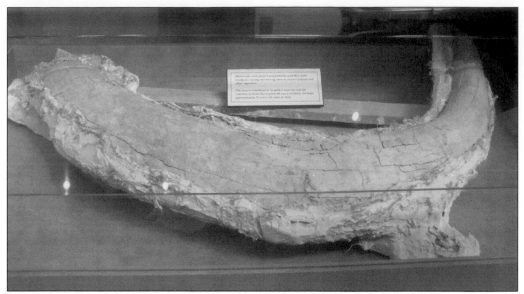

Decades after the lake disappeared, Parker became home to woolly mammoths and other wandering mammals. This bone, tusk, and piece of a mammoth head, currently displayed at Parker Town Hall, were discovered at a site northwest of town. (Author's collection.)

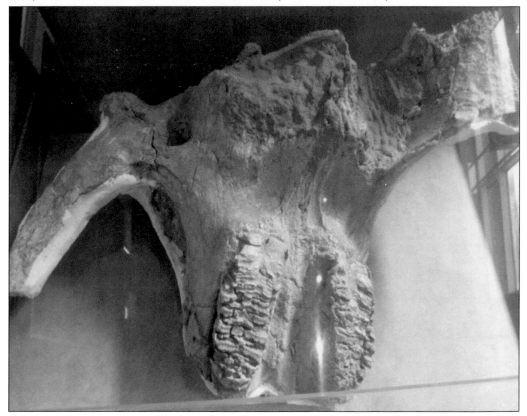

A few years ago, when excavating for a subdivision extension, a construction company uncovered these mammoth remains. The town was able to keep these pieces for display. (Author's collection.)

This petrified log west of the current city hall is an example of the rock common in the area. Petrified wood like this was used by Native Americans for spear and arrow points. Later, the rock was used for jewelry and decorative purposes. (Author's collection.)

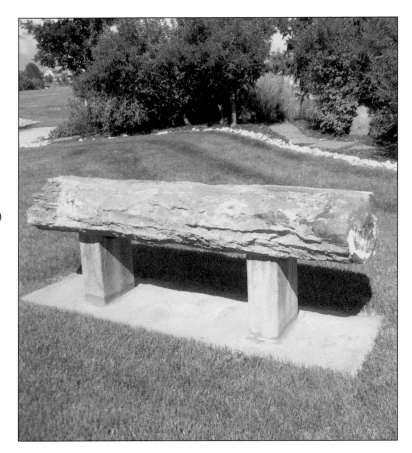

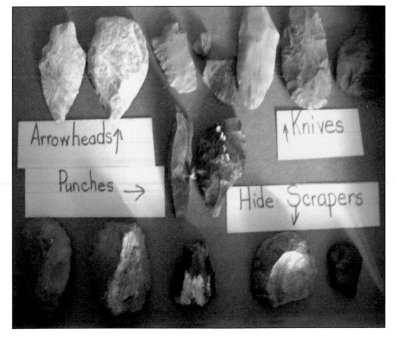

Arrowheads↑

Punches →

↑Knives

Hide Scrapers↓

Around 2,000 years ago, migrating bands of Native Americans settled near Parker. The area not only provided the tribes with a steady supply of petrified wood for hunting points, but also fresh water, ample game, and building materials to construct protective dwellings. Some of the points used for atlatls and arrow points are shown here. (Author's collection.)

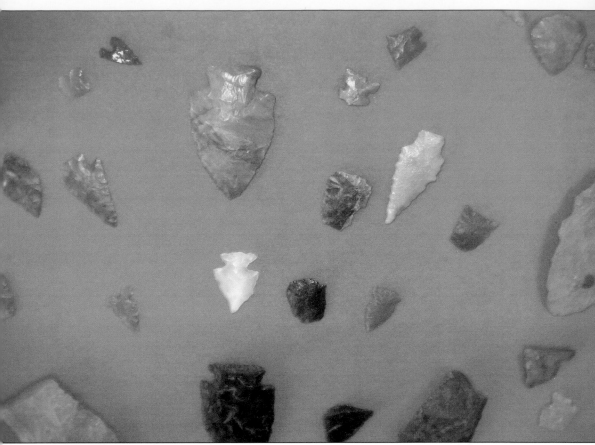

Fine points like these were used for hunting fowl and small game like rabbits. Tools such as hide scrapers, punches, and axe heads were found at sites known to be used by the early tribes. (Author's collection.)

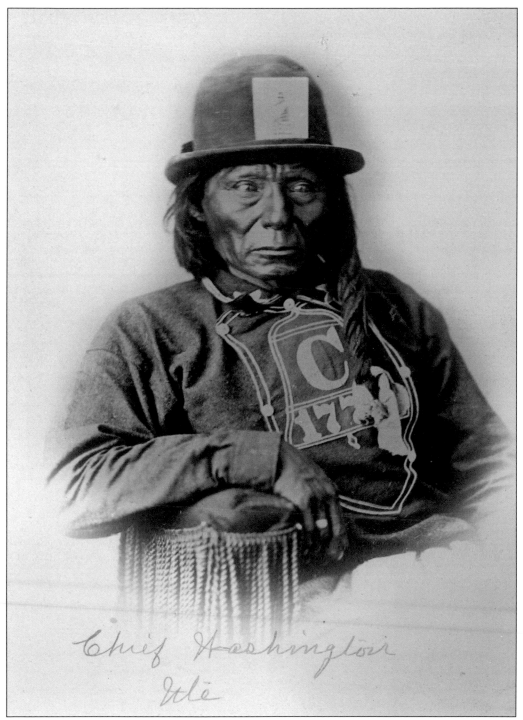

Chief Washington
Ute

By the time pioneers entered the area, only a few bands of Native Americans remained in the area. Chief Washington and his Ute tribe camped near Cherry Creek in winter and passed by the Tallman cabin in spring. Chief Washington's braves liked Elizabeth Tallman and, according to her account, once invited her to a scalp dance. (Courtesy of the Denver Public Library.)

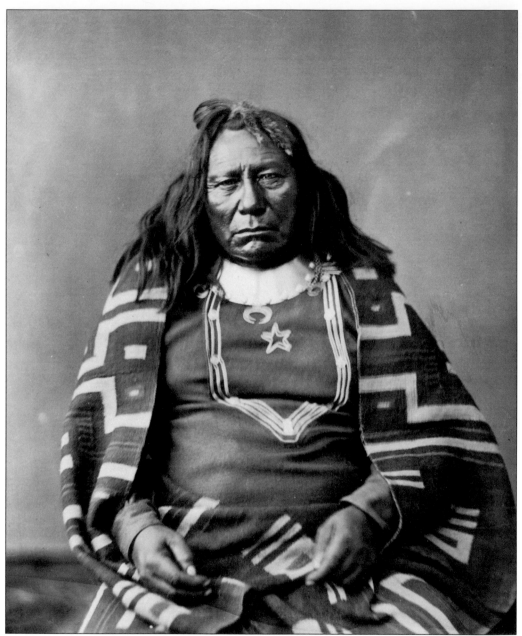

Chief Colorow remained in the Parker area until the treaty in the 1800s was signed, and the Ute tribes were relocated to southwestern Colorado in the Durango-Cortez area. Native American groups were not hostile to Parker-area residents, and the pioneers remained at peace. (Courtesy of the Denver Public Library.)

Two

TRAILS, STAGES, AND THE RAILROAD

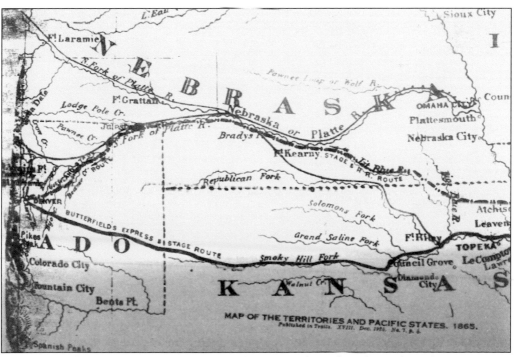

Travelers to the early West seeking gold in the 1859 rush used tracks, such as the Trappers or Cherokee Trails, made by migrating Native Americans, those seeking game, and the occasional trapper or explorer. Sometimes a mere game trail guided the adventurer to his or her destination. Branches of the Smoky Hill Trail left the Smoky Hill River and followed available water sources to the base of the Rocky Mountains. (Author's collection.)

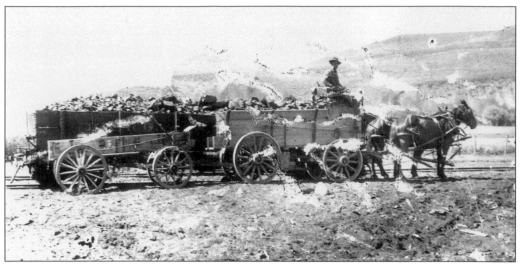

When gold was discovered in 1859 at nearby Russellville, Easterners flocked to the Parker area. Many of the prospectors walked from the Mississippi River, pushing wheelbarrows carrying their digging supplies. Few were able to afford passage on a stagecoach or purchase a horse. Some came in freight wagons like the one seen here, hoping to later use the wagons to earn a living. (Author's collection.)

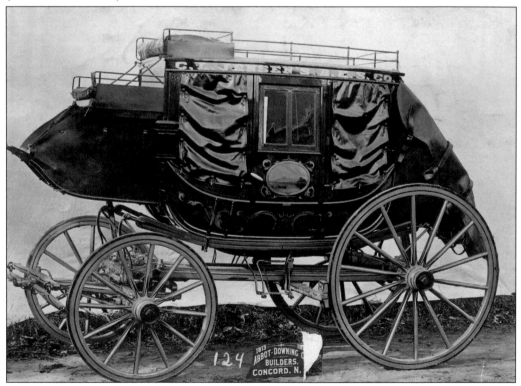

Stagecoaches brought wealthy pioneers to the new land. Most who were able to afford the stage fare did not come to dig for gold but were merchants who came to sell supplies to miners. Most of these travelers did not stay in the Parker area but gravitated to Denver, where miners purchased their wants and needs. (Courtesy of the Denver Public Library.)

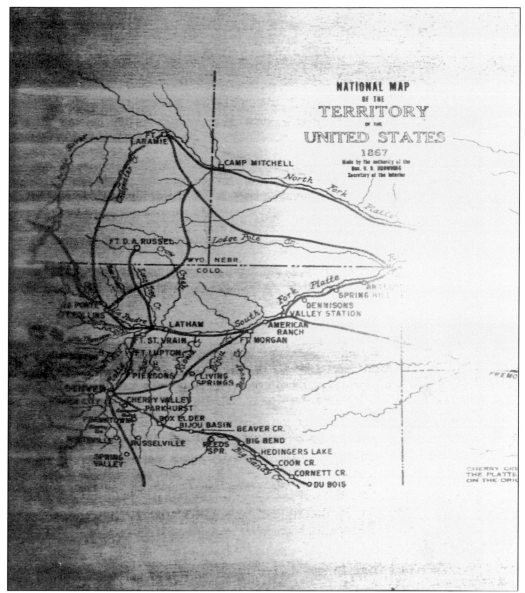

New residents followed trails established by Native Americans and early explorers. The Cherokee Trail, which follows the south branch of the Smoky Hill Trail, was used long before gold seekers came to Colorado. (Author's collection.)

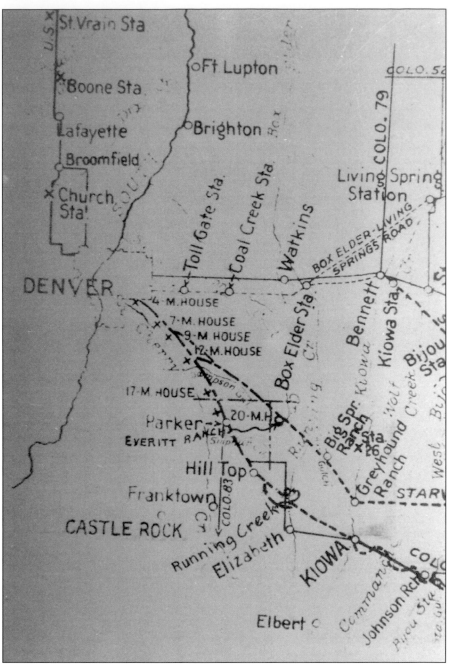

This map of the trails drawn by Dr. Margaret Long for her book *The Smoky Hill Trail* shows the three branches of the trail pioneers traveled. The south branch came through Parker. The middle branch, also known as the Starvation Trail, passed about six miles from town and earned its name because of the travelers who died along the trail. These were only three of the many trails that crossed the Plains for 687 miles from the Missouri River to the gold fields. Surveyed in the 1880s by Second Lieutenant Julian R. Fitch of the US Signal Corps, the trail was used for freighting as well as stagecoach travel. Over one billion pounds of freight came to the area via these trails. (Courtesy of Dr. Margaret Long.)

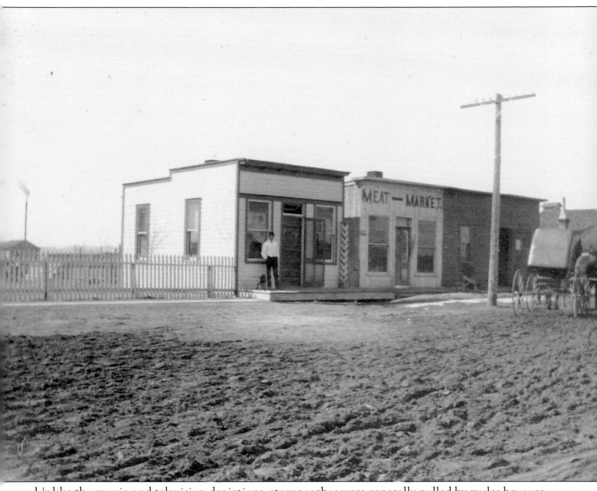

Unlike the movie and television depictions, stagecoaches were generally pulled by mules because they were more sure-footed than horses. If a mule stepped into a hole on the prairie, it was less likely to break a leg. Animals with broken legs had to be abandoned along the trail and severely limited the speed of the coach. Stages were usually Concord coaches like the one at right, with large wheels in the back and smaller ones in front. (Courtesy of Marilyn Parker.)

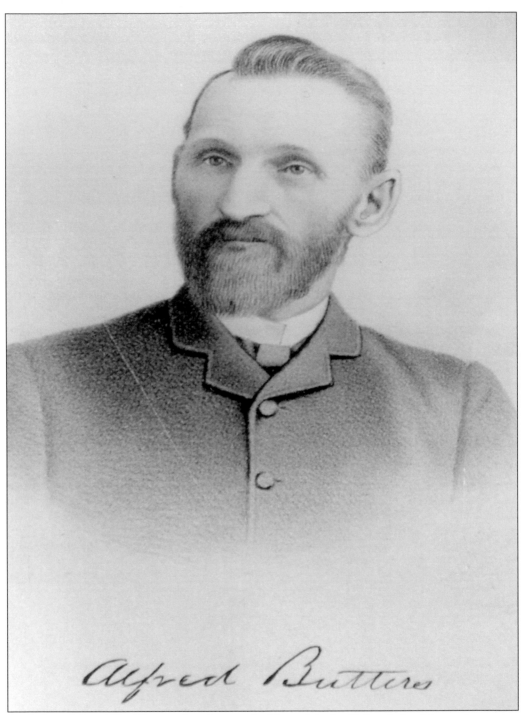

Alfred Butters

It is believed that Alfred Butters, later known for his work in the Colorado Legislature for passing cattle-branding laws, was the first proprietor of the Pine Grove-Parker Post Office. Unlike modern post offices, the Pine Grove station had no regular service and acted as a spot for those coming down the trail to leave communication for those arriving later. The original station was built south and slightly east of Parker on the hill overlooking the present town. (Author's collection.)

Butters traded the post office to a man by the name of Goldsmith. Goldsmith then sold the post office to the George Long family, who moved the building to its present location on Mainstreet (formerly Euclid Avenue) in Parker. The establishment welcomed its first guests in 1865, when Elizabeth Penneck and her sister Mary sought refuge in a cold November rainstorm. The Longs slept outside under a wagon while Elizabeth and Mary made themselves comfortable inside the small building pictured. (Author's collection.)

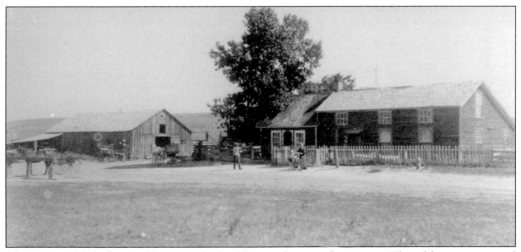

The Longs added a large addition to the building in the next three years. The addition contained sleeping rooms on the lower level and a large second-story ballroom. At Christmas, New Years, Independence Day, and Thanksgiving, the house was transformed into a community gathering place, as a huge dinner and dancing celebrated the occasions. (Courtesy of the Colorado State Historical Society.)

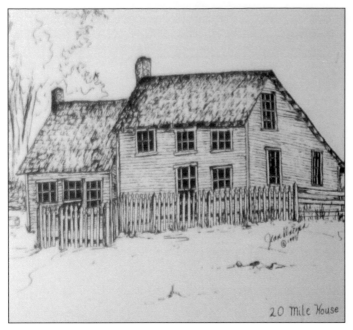

By 1868, the 20-Mile House, named for the distance of the house from Denver city limits at Colfax and Colorado Boulevards, changed hands again when George Long traded it to Nelson Doud for a team of horses. By this time, the 20-Mile House was a grocery store, post office, and blacksmith shop, as well as the stage stop and hotel. (Courtesy of Bob and Josie Fetters.)

20 Mile House

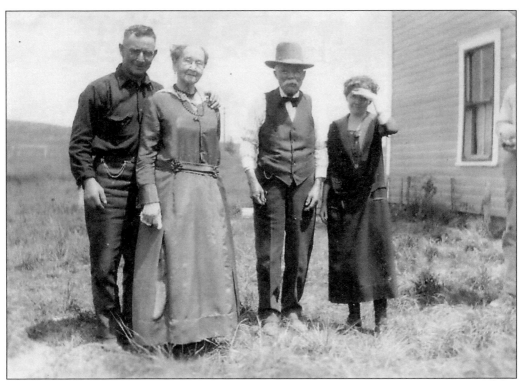

The 1859 population of Parker is listed in the "Colorado State Business Directory" as one. John Tallman (second from right), future husband of Elizabeth Penneck, is listed as the single resident. John raised Hereford cattle and worked at several sawmills in the area. (Author's collection.)

By the early 1870s, the population of the area had increased. Bachelor George Parker established a timber claim on the east side of what is now Highway 83. He constructed a saloon and slowly began to sell city-sized lots to those interested in building. George, a Civil War veteran, walked with a cane. Eventually he sold plots of land to new residents who established a grocery store, lumberyard, saloon, creamery, and various other businesses. (Courtesy of Marilyn Parker, the Anna Rowley collection.)

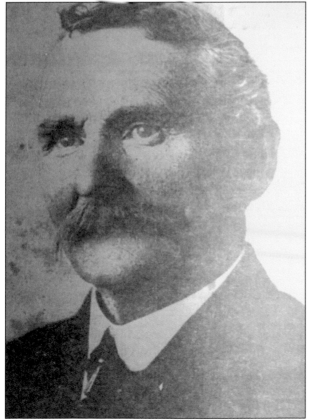

In 1874, James Sample Parker joined his brother George in the area when he purchased the 20-Mile house from the Douds. While running the Kiowa, Colorado, stage station, James had purchased a homestead plot across the road from the 20-Mile House. Documents conflict about the actual date of the purchase, but most agree this happened in 1871. (Courtesy of Betty Naugle.)

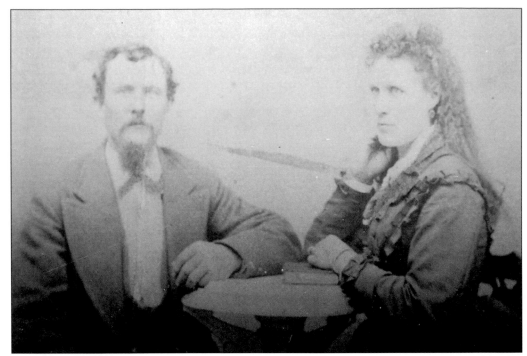

In addition to being the postmaster and 20-Mile House proprietor, James Sample Parker sold right-of-ways for a water ditch and the Denver and New Orleans Railroad. This insured the railroad track would swing away from its course along Cherry Creek and run through the newly formed town. He is shown here with his wife, Mattie. (Courtesy of Betty Naugle.)

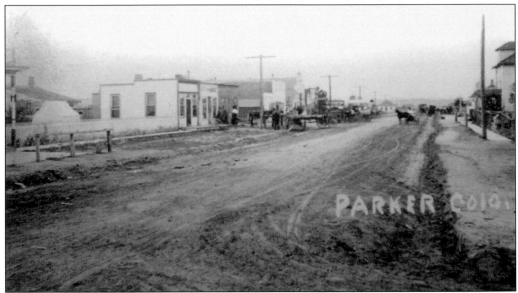

Former Colorado governor John Evans envisioned a rail line that would run south out of Denver, terminating at the Gulf of Mexico. From this dream, the Denver and New Orleans line was formed. Running south along Cherry Creek, the standard-gauge trains would provide Parker residents with an easier way to move their products. The town grew to a busy place as the supporters envisioned. (Author's collection.)

James Sample Parker sold the right-of-way for the line to the Denver and New Orleans Railroad for $1, insuring that the tracks would swing away from Cherry Creek and travel through the small village. (Courtesy of Betty Naugle.)

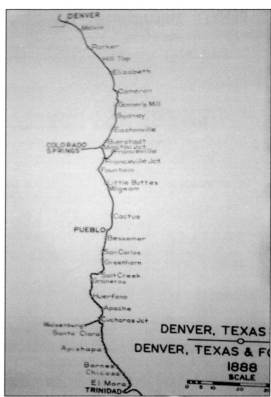

The impending rail line encouraged a building boom as a train station, water tower, hand-dug well, pump house, and section house were built to serve the line. Livestock pens and a warehouse were added later. The man sitting on the baggage cart with the cane has been identified as George Parker. (Courtesy of the Colorado State Historical Society.)

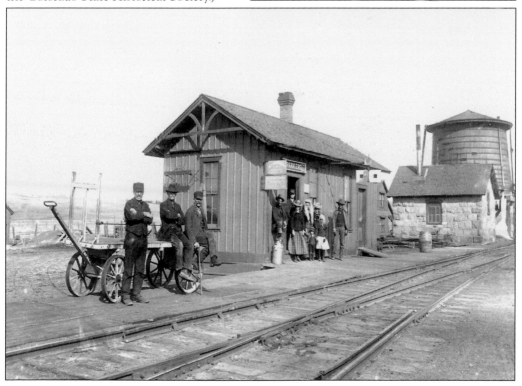

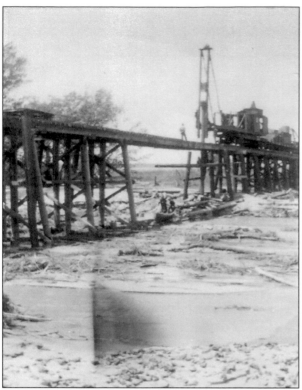

Despite reporting in 1884 that the line had experienced four million passenger miles and moved five million ton-miles of freight, the line never prospered. In 1912, a large flood down Cherry Creek washed out the longest trestle, 687 feet, on the line. Steam-driven pile drivers had to be used to replace the trestle and other washed-out sections. (Courtesy of Marilyn Parker, the Anna Rowley collection.)

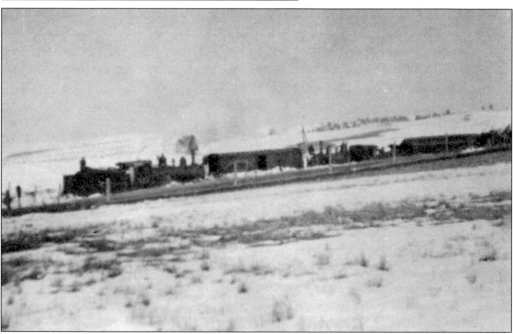

Due to the five-percent incline from Parker to Hilltop, a second engine was kept in Parker and attached to the train. When the train reached Hilltop, the second engine was detached and backed down the track to Parker. Occasionally, trains were caught in winter blizzards. This train was en route to Hilltop when it was stranded in the snow. (Courtesy of Evelyn Christiansen.)

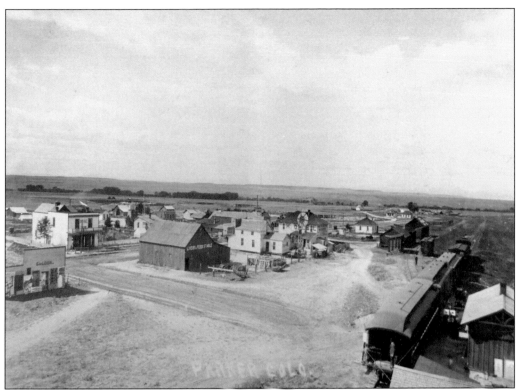

A perch on the water tower provided this view of Parker. The photograph shows George Parker's saloon in left foreground, the Cottage Hotel, the livery stable, the corner of a house behind the stable, a grocery store, the Rhode Island Hotel, the railroad sheds, the post office, and in the distance the 20-Mile House. (Courtesy of Marilyn Parker, the Anna Rowley collection.)

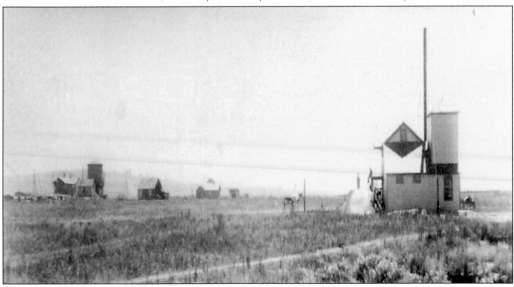

This earlier photograph shows the lack of buildings when the railroad first came to Parker. The Littleton creamery and the railroad buildings are the only structures shown in this photograph. (Courtesy of Marilyn Parker, the Anna Rowley collection.)

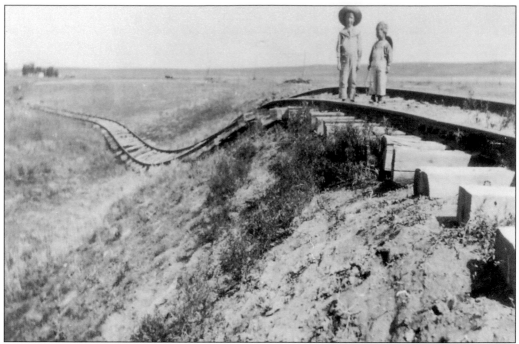

In July 1912, local flooding damaged the tracks. Debris from the flood washed down small gulches as well as Cherry Creek and piled up along the track. The section house can be seen behind the tracks. (Courtesy of Marilyn Parker, the Anna Rowley collection.)

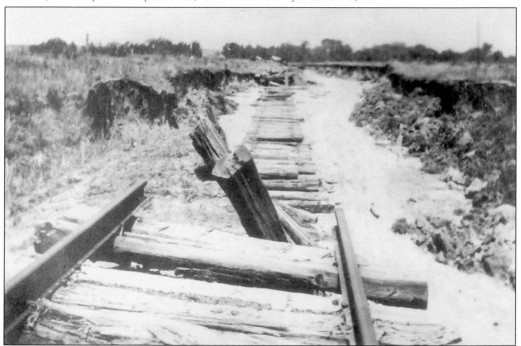

Spring and summer floods continued to plague the line with washed-out track and expensive repairs. These problems cost the floundering line more money than it was making in the early 1900s. (Courtesy of Marilyn Parker, the Anna Rowley collection.)

One flood managed to wash out the important scales used to weigh freight and livestock before shipping. This disaster cost the line more money, as a replacement needed to be found. (Courtesy of Marilyn Parker, the Anna Rowley collection.)

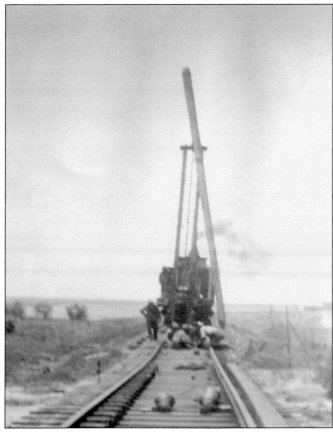

This steam-driven pile driver was brought in to repair the longest trestle. Locals were fascinated with the repairs and took photographs of the pile driver. (Courtesy of Marilyn Parker, the Anna Rowley collection.)

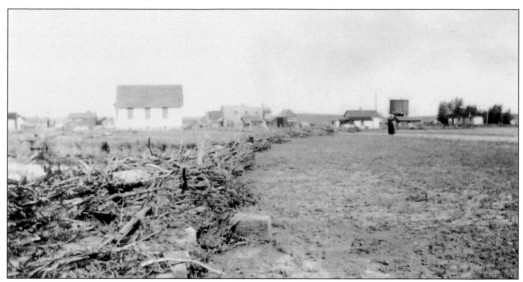

The line was never profitable, and when the tracks washed out in 1935, the line was closed and most of the track pulled up the following year. (Courtesy of Marilyn Parker, the Anna Rowley collection.)

In many places along Hilltop Road, evidence of the defunct rail line still exists. Spots where cuts or small trestles were placed are visible. This photograph shows slag (coal) that was thrown from the hopper. (Author's collection.)

Three

PARKER'S PIONEERS AND AGRICULTURE

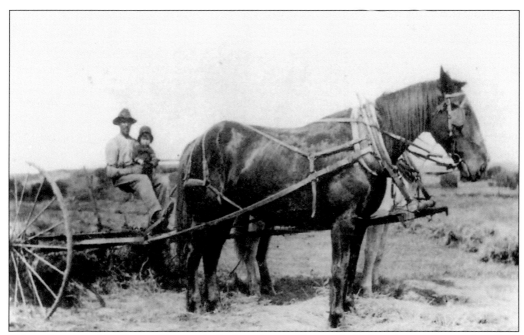

When dreams of finding gold were dashed against reality, early Parker pioneers turned to their former occupations. Since a large percentage of the early residents were Swedish, Danish, or Norwegian, it was a natural segue for them to establish dairies. Lewis Christiansen, shown here with his grandfather, entered dairy farming at an early age. (Author's collection.)

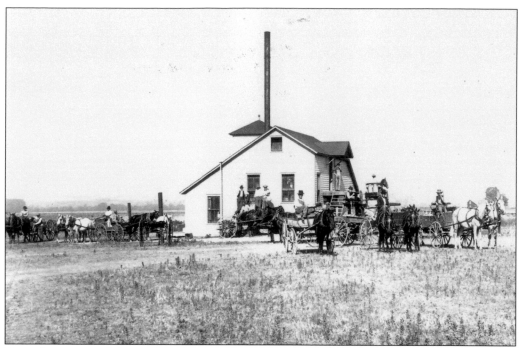

Dairy farms created the need for a creamery in the area. The Littleton Creamery collected milk and cream from local dairy farmers, and it produced cheese and butter, which was sent to the rapidly growing Denver population. It also made ice cream, much to the delight of Parker residents. (Courtesy of the Colorado Historical Society.)

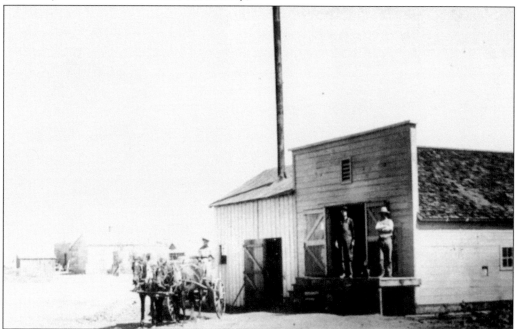

Sometime later in the early 1900s, a second creamery was added to handle the surplus milk and cream from farmers. It was located on Pilgrim's Place and sold most of its products locally. (Courtesy of Gertrude Kodziel and Larry Smith.)

Horse breeding was also a popular occupation for early Parker residents. These horses raised east of town were used to pull wagons for the American Tea and Coffee Company. (Author's collection.)

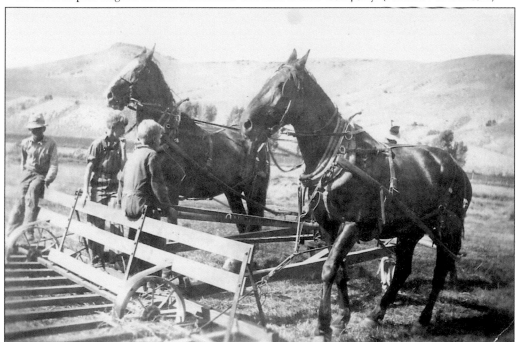

With horses and cows to feed in winter, farmers in the area used the fertile bottomlands along Cherry Creek to raise alfalfa hay to supplement the native grass. Occasionally, farmers planted wheat and oats as cash crops. (Author's collection.)

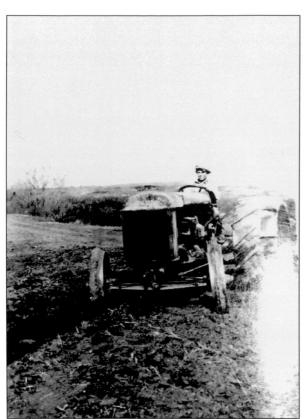

All too soon, youngsters like Lewis Christiansen learned to drive a tractor and plow a straight furrow in order to help with the farm or ranch. Corn or sorghum supplemented alfalfa as a food crop for livestock. In good years, when alfalfa was sufficient, corn and sorghum could be used as cash crops and sold to finance the family. (Courtesy of Evelyn Christiansen.)

Bob Hawkey, shown here on his horse Sunday, later retired from ranching and became the blacksmith in Parker. He supplemented his income by providing the railroad with antelope to feed their workers. To many local residents, he was known as "Antelope Bob." (Courtesy of Vera Siebert.)

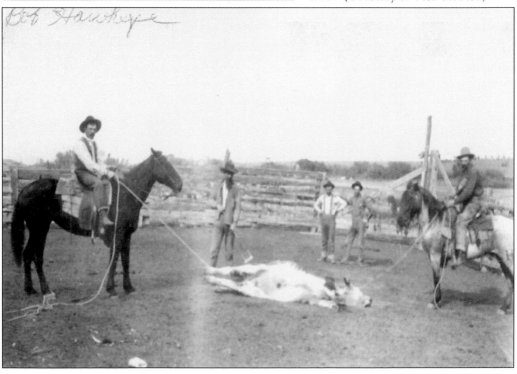

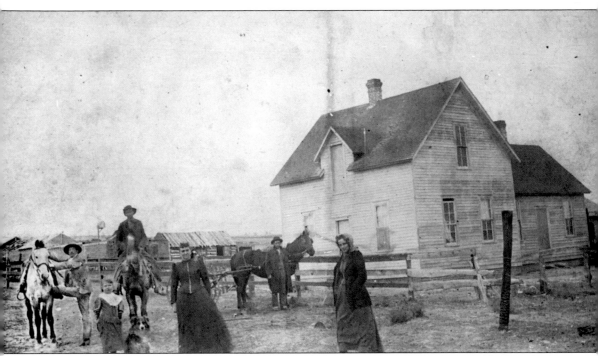

Families combined farming and ranching in order to survive in the new area. Pictured here is the Rowley family in their yard before the men rode off to check on cattle. (Courtesy of the Denver Public Library.)

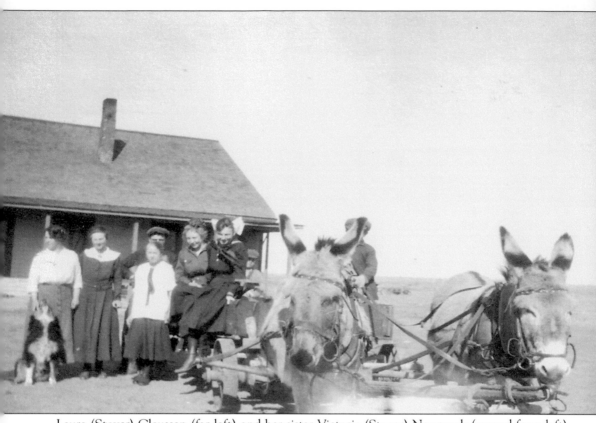

Laura (Stover) Claussen (far left) and her sister Victoria (Stover) Newcomb (second from left) are pictured here with a frontier family mostly populated by women. This was not an unusual scenario; in one case, three Swedish sisters homesteaded while their husbands worked over 100 miles away. (Courtesy of Marilyn Parker.)

Four

EDUCATING PARKER'S CHILDREN

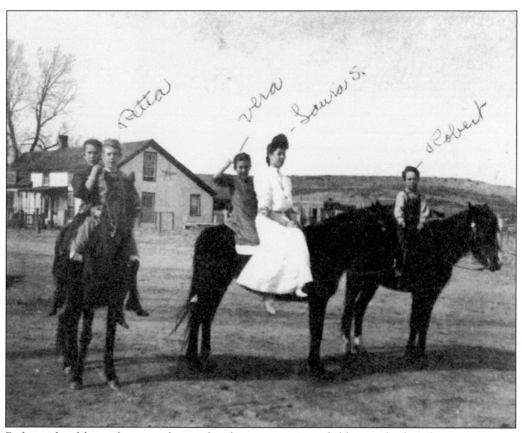

Before school buses became the mode of transportation, children rode their horses to get to school. This photograph shows the Rowley children on their way home from school. From left to right are unidentified (behind), Retta (Rowley) Kime (front), Vera (Rowley) Siebert, teacher Laura (Stover) Claussen, and Robert Rowley. (Courtesy of Vera Siebert.)

Fonder School was the first school in the Parker area. In the mid-1860s, Miriam Fonder decided the local children were becoming ruffians and established a school in her home. Shortly after, a schoolhouse was built, but it burned down. The second school was constructed of rhyolite rock brought from Castle Rock. (Courtesy of the Denver Public Library.)

Children continued to be educated in the Fonder School until the 1930s. Classes dwindled, and upkeep for the facilities became more expensive for such a small number of students. (Courtesy of the Douglas County Preservation Committee.)

When James Sample Parker's daughter Edith (pictured) was old enough to attend school, the Parkers decided that traveling the 10 miles to the Fonder School was not wise, so James Sample Parker built the town's first school on the homestead land he had originally purchased in 1871. (Courtesy of Betty Naugle.)

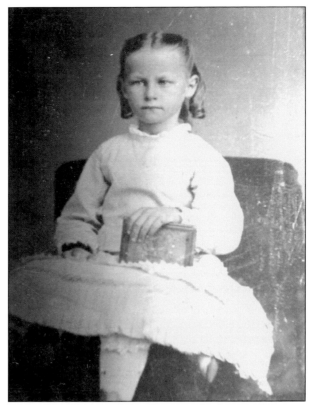

James Sample Parker built the new school across from the 20-Mile House and furnished it with books and desks. He also paid the teacher's salary for the year. Pictured here is one of the early classes; Edith Parker and the three Rowley children are among the students shown in front of the new school. (Courtesy of the Colorado Historical Society.)

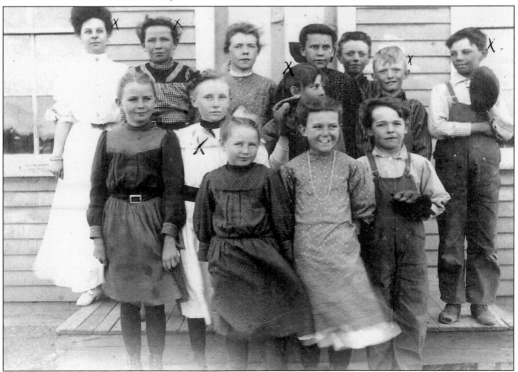

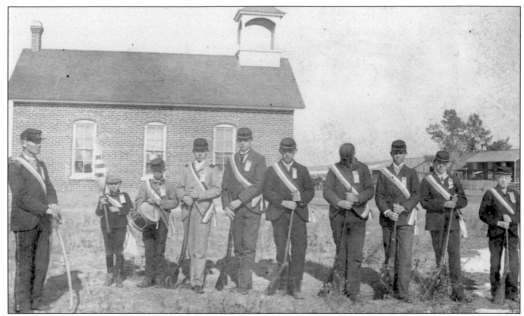

Boys in this class received military training in case of problems with the Native Americans or other threats. (Courtesy of the Colorado Historical Society.)

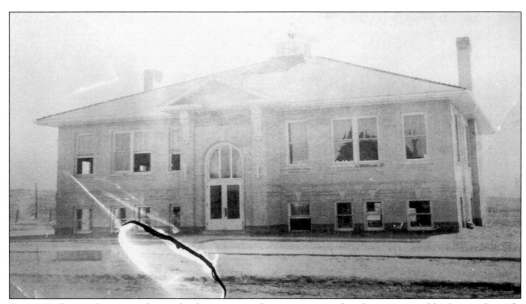

By 1915, the student population had outgrown the one-room school constructed by James Sample Parker. An increasing number of students desired to be educated beyond the eighth grade, so land on the east side of current Highway 83 was acquired. This building, now the Mainstreet Center, housed both elementary and high school grades. (Courtesy of Gilbert Carlson.)

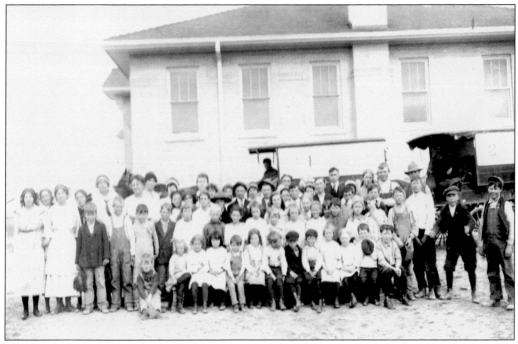

Horse-drawn school buses brought students from outlying areas. Since the building was larger, some of the smaller one-room schools were closed. Pictured here are the buses and their drivers, students, and the entire staff, posing on the west side of the building. (Courtesy of Marilyn Parker.)

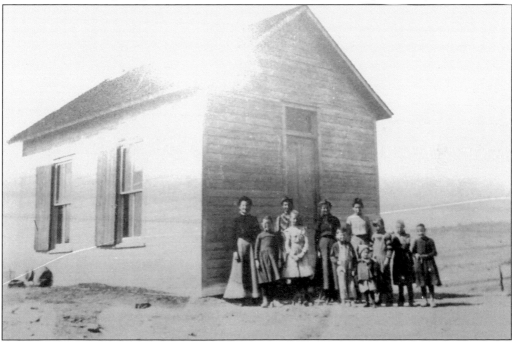

The children at Plainfield School, shown here, suffered a tragedy when their teacher froze to death in a blizzard. They were relieved and happy to travel to Parker to attend school. (Courtesy of Gilbert Carlson.)

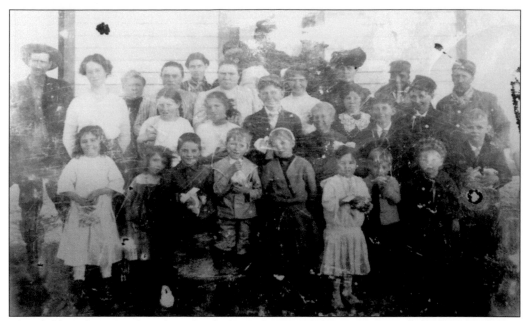

The children from Rattlesnake School, shown here at a Christmas party, did not attend Parker School until the 1940s. Rattlesnake served students in grades 1–8, while Parker was 1–12, so Rattlesnake students had to attend Parker for high school. Since the school district did not send the buses that far east, students boarded with Parker residents or stayed at the local hotels during the school week and went home on weekends. (Author's collection.)

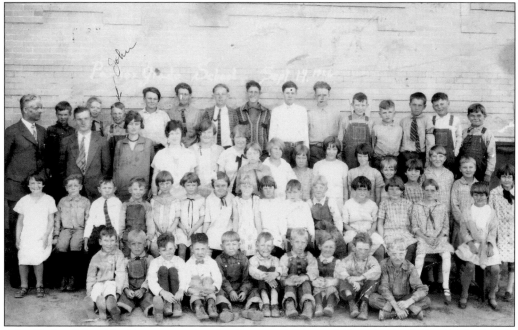

After Parker School had been operating for 11 years, children of all grades (including high school), teachers, and the principal posed for this photograph on the west side of the school. Gunhild (Kraglund) Dransfeldt, who was then living at the 20-Mile House, is eighth from the left in the second row. (Author's collection.)

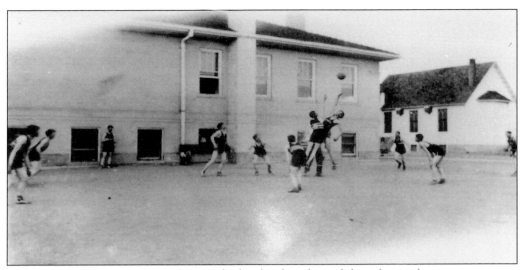

Despite Parker residents' love of sports, high school students did not have a legitimate court to play basketball. Students practiced on the blacktop behind the school or in the railroad sheds down the street. (Author's collection.)

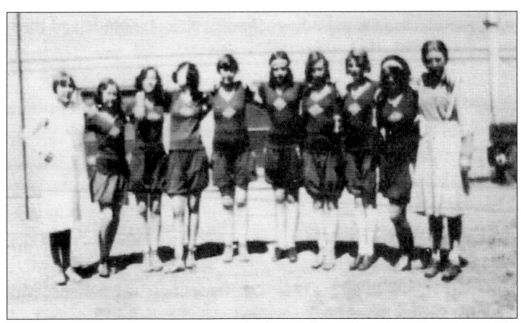

For a brief time, the team met competitors in the dance hall room above August Deepe's store. The floor was only a half-court, but it was still a place to enjoy the basketball games. Even the girls' team, shown here in their wool bloomers, took on the competition. (Courtesy of Holly Wallden.)

When the railroad closed down, the old railroad sheds were used as a basketball court. Eventually, the sheds were moved behind the schoolhouse. Players complained about the splinters they picked up from the old floors, but the games continued. (Courtesy of Marilyn Parker.)

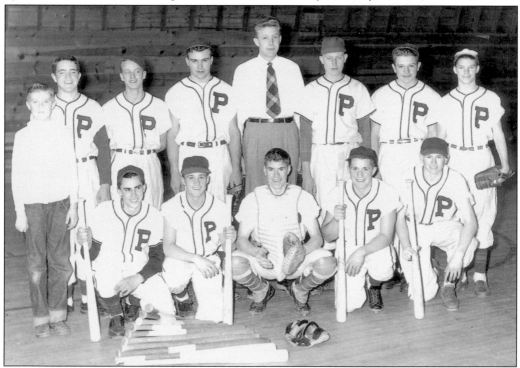

Baseball was a favorite sport in the community. The town teams, everyone's favorites, consisted of young men from the community and high school baseball players who excelled at the game. (Courtesy of Marilyn Parker.)

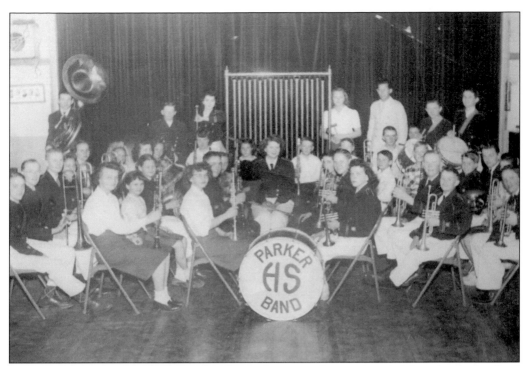

Parker School carried on the musical traditions begun in the town's early life with a high school band and choir. But, the band, choir, and dramatic endeavors were curtailed by the lack of a stage. Performances were held in one of the high school's upstairs rooms, but space was a continuous problem. (Courtesy of Marilyn Parker.)

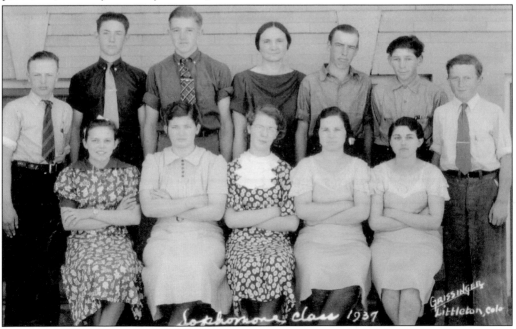

Each year, classes posed against the west wall of the school for yearbook photographs. Pictured here is the Parker School junior class in 1926. (Courtesy of Marilyn Parker.)

In 1949, the problem of no gymnasium became acute. A bond issue to build a gymnasium with a stage was defeated by a small margin. With the exception of Hilltop School, the one-room schools had been closed, and students within a 10-mile radius were being bused to Parker. Times were hard; the area was in the middle of a severe drought. Farmers and ranchers did not have money, but they had time and a vision for their children and their neighbors' children. The idea of a community building was presented to the public. (Courtesy of Marilyn Parker.)

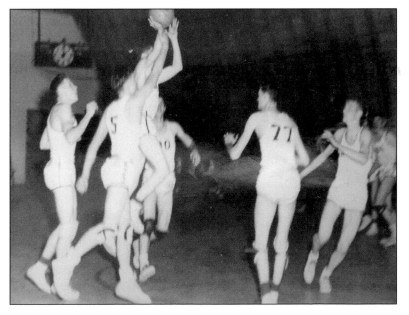

The boys' basketball team was a source of enjoyment for the entire community. Whether playing above the Deepe store, in the old railroad sheds, or in the new community building, the team excelled. The year after the community building was completed, the team captured first place in its division. (Courtesy of Marilyn Parker.)

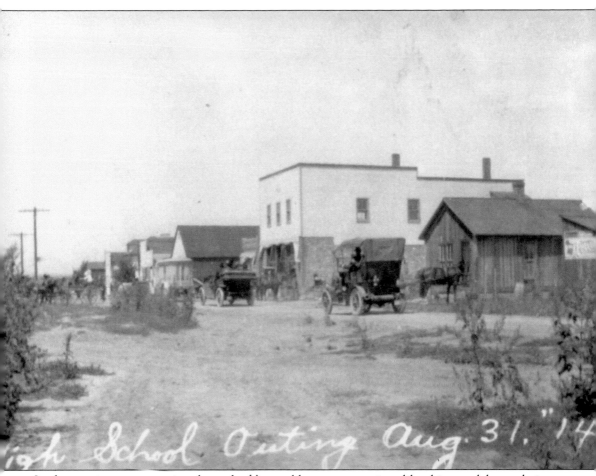

In the previous years, senior classes had been able to go on outings like this to celebrate their graduations. But, as the school and town grew, this activity was not possible. (Courtesy of Marilyn Parker.)

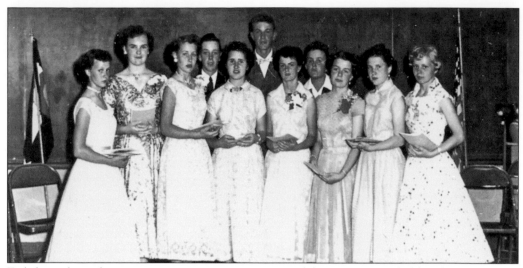

Eighth-grade graduations, or continuations, were part of the many events held at the community building. This 1954 continuation class was photographed in one of the schoolrooms, but the ceremonies were held down the street. Pictured here from left to right are (first row) Leila Cherne, JoAnn "Josie" Dransfeldt, Isella Smith, Alice Hess, Barbara Hendricks, Gwendolyn Simmons, Harriet Jeffers, and Claudia Weimer; (second row) Dale Atteberry, Wayne Noe, and Charles Everitt. (Courtesy of Bob and Josie Fetters.)

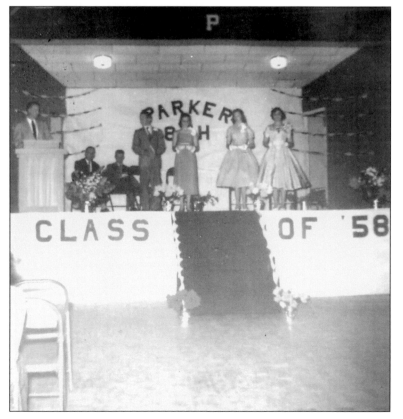

Classes were small. This ceremony for the graduating eighth-grade class of 1958 only celebrated the achievements of four students. Graduates are, from left to right, Rick Race, Sharon McKinster, Joe Marie Hall, and Sandra Everitt. (Author's collection.)

In 1958, prom queen Josie (Dransfeldt) Fetters and king Wayne Noe enjoy a dance, unaware of the that their school would soon close. Later that year, a new superintendent of schools announced that Parker High School would close in the fall of that year. High school students would be bused 27 miles to Castle Rock in a consolidated district move. The edict would last for 25 years until Ponderosa High School opened in 1983. (Courtesy of Bob and Josie Fetters.)

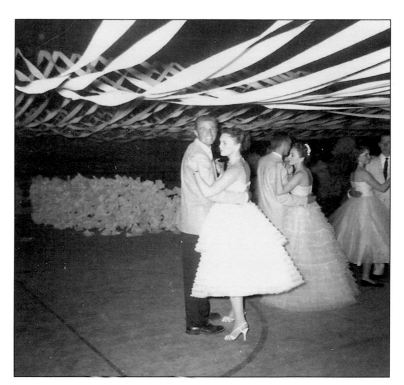

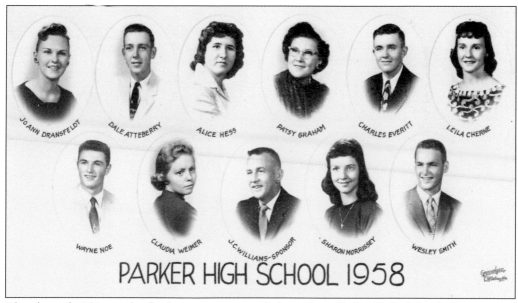

JOANN DRANSFELDT DALE ATTEBERRY ALICE HESS PATSY GRAHAM CHARLES EVERITT LEILA CHERNE

WAYNE NOE CLAUDIA WEIMER J.C. WILLIAMS-SPONSOR SHARON MORRISSEY WESLEY SMITH

PARKER HIGH SCHOOL 1958

The class of 1958 was the final group to earn a diploma from Parker High School. (Courtesy of Bob and Josie Fetters.)

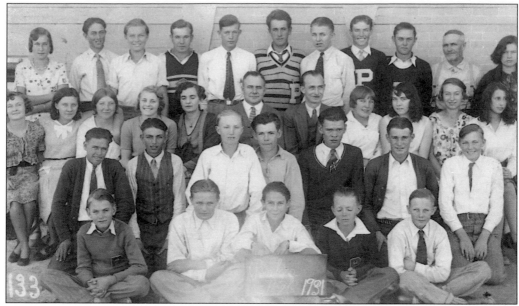

During the Great Depression and into modern times, the schools stood as a symbol of everything positive in the Parker area. Students did not drop out; an education was important. (Courtesy of Marilyn Parker.)

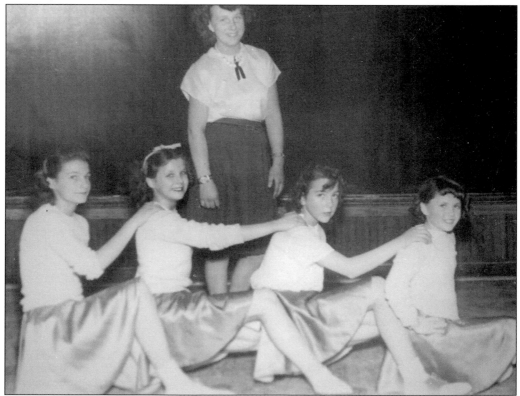

Every extracurricular activity was important to parents and students. These cheerleaders honed their leadership abilities in the squad. (Courtesy of Marilyn Parker.)

Five

EARLY BUSINESSES

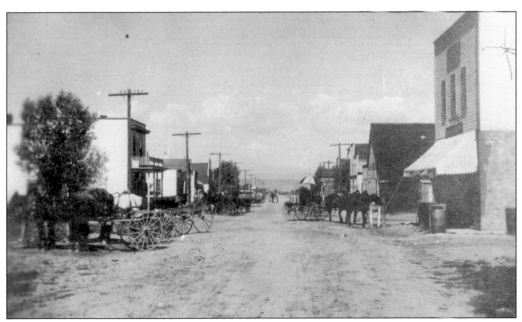

With the coming of the railroad, business in Parker thrived. The line provided citizens with easier access to groceries and hardware, and two hotels were needed to accommodate train passengers. By the turn of the 20th century, Colorado and Parker had become a draw for Easterners with consumption (tuberculosis). The rail line brought new residents and commerce. (Courtesy of Marilyn Parker.)

One of Parker's first businesses actually began south of town. Due to the region's high, dry air, Colorado became a destination for hundreds of Easterners afflicted with tuberculosis. The Ponce de Leon Chalybeate Springs twin houses were established by the E.H. Allison family around 1885. Most of the people who came to be cured of the disease were from New Hampshire, among them the Allisons. The houses offered expert care and a small hot spring to nurse patients back to health. (Courtesy of Bob and Josie Fetters.)

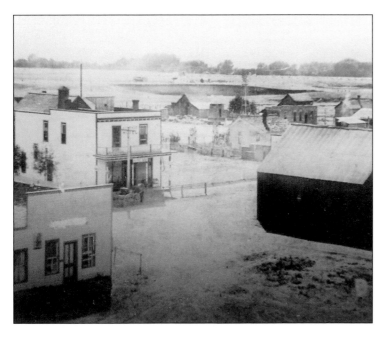

Back in town, the Cottage Hotel housed a restaurant and saloon in addition to upstairs rooms. The building was owned by a series of proprietors and is listed in the "1912 Colorado State Business Directory" as being owned by the Rubbes. In the late 1920 or early 1930s, Franklin Harn recalls that his mother purchased the hotel when they spent the night there on the way to Fort Collins, Colorado. They never reached Fort Collins on that trip. (Courtesy of Marilyn Parker.)

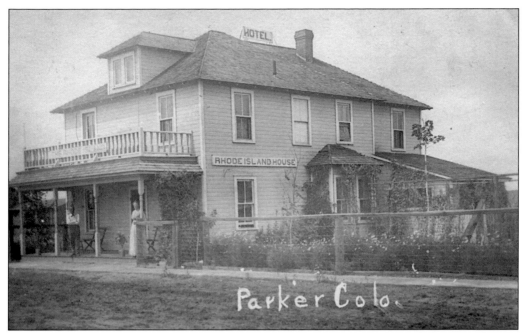

The Rhode Island Hotel was first listed in the "1900 Colorado State Business Directory," with H.M. Goddard as the proprietor; however, deeds of record do not show the transfer of the property from George Parker to H.M. Goddard until 1906. In the 1912 directory, Goddard is listed as justice of the peace and owner of the livery stable and hotel. (Courtesy of Marilyn Parker.)

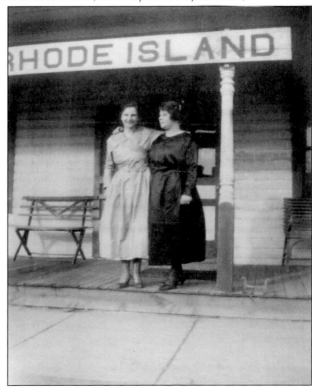

Many early Parker residents had ties to the Rhode Island Hotel. Sisters Victoria (Stover) Newcomb (left) and Laura (Stover) Claussen, shown here, may have been visiting Victoria's husband, who was the barber at the hotel. (Courtesy of Marilyn Parker.)

The Rhode Island Hotel survived as a rooming house well into the 1960s, when single teachers stayed in the upstairs rooms during the school term. Part of the building was later used as a hardware and liquor store, and a small outbuilding on the property became Parker's first library in the late 1960s. Today, the building is used for office spaces upstairs and a flower shop, coffee shop, and upscale boutique on the street level. (Courtesy of Marilyn Parker.)

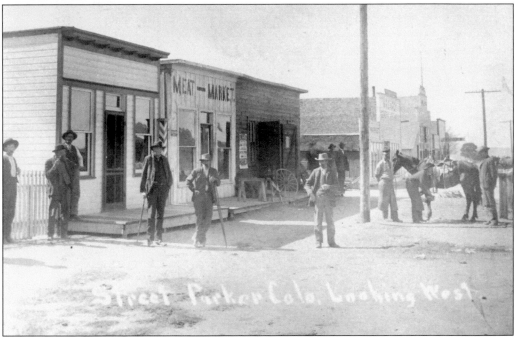

These men are congregated outside three businesses considered necessities. The barbershop, meat market, and blacksmith shop were established early in the 20th century. Pictured here from left to right are Frank Rowley, unidentified, John Lewis, unidentified, George Parker, August Rueter, and two unidentified men. The photograph also shows the D'Arcy and Lewis grocery stores down the street. (Courtesy of Marilyn Parker.)

The house to the right in this c. 1920 photograph is likely the oldest building in town. The house was moved to its present position from the railroad right of way in the 1880s. Used as an ice cream shop, later as a duplex home, and currently a hair salon, the house has witnessed much of Parker's history. The building to the far left is the blacksmith shop. To know more about the building in the center, see page 63. (Courtesy of Marilyn Parker.)

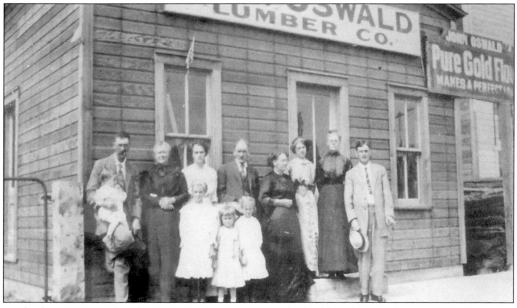

In the late 1910s and early 1920s, Parker experienced a building boom of sorts. Little is known about the family pictured here in front of the Oswald Hardware. Oswald was one of the owners; another well-known resident, August "Gus" Deepe, owned the building later. (Courtesy of Marilyn Parker.)

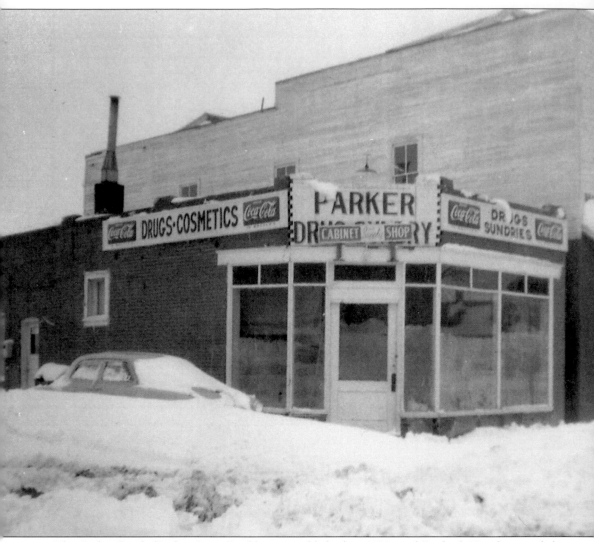

The Parker Bank (Parker State Bank) was established in 1923, and Fredrick Hood secured the financing for it and was the early teller. The bank had a rather rocky history. In 1927, robbers practiced parking across the street and then racing east out of town, standing on the car's running boards around sharp corners to prevent tipping. On the day of the crime, they forced the young female teller into the safe and robbed the bank. (Courtesy of Marilyn Parker.)

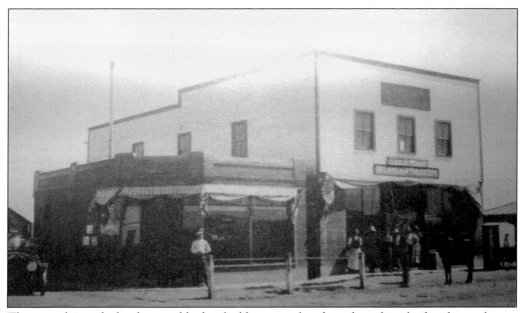

The second time the bank was robbed, valuables were taken from the safe and safety deposit boxes. Combined with the stock market crash in 1929, the bank was not able to recover and closed its doors. Residents were forced to travel over 20 miles to the Littleton bank in Littleton, Colorado, or to the Douglas County Bank in Castle Rock. Parker would not have another bank until the Bank of the West was established by a local consortium spearheaded by Fred Dransfeldt in the early 1970s. (Courtesy of Marilyn Parker.)

Unlike banks, grocery stores had few problems establishing a business in Parker. The D'Arcy and Lewis stores stood next to each other on the street, and the locals patronized both. According to one older resident, his mother sent him to purchase supplies from one store on one day and the other store the next day. (Courtesy of the Douglas County History Research Center.)

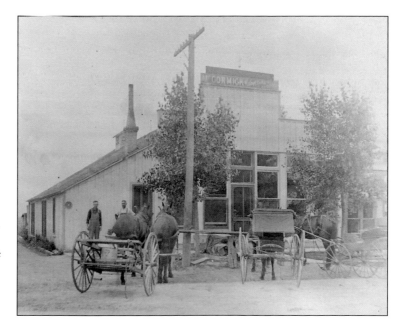

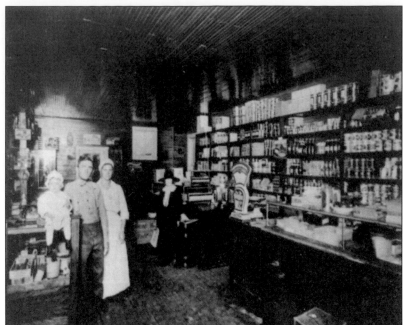

A young bridge builder named Burt Hall decided to put down roots in Parker and purchased a third grocery store from Mrs. Bertram. Burt Hall's store was a favorite with children because he had a large counter of penny candy. Burt Hall retired in 1959 and sold the building to his competitor, Rupert Weimer. (Courtesy of Marilyn Parker.)

For a short time, a fourth store appeared under the proprietorship of V. Frye. Frye Mercantile was eventually purchased by Rupert Weimer, who moved from Elbert, Colorado. The store had the added attraction of a walk-in freezer, which meant Weimer's store was able to provide fresh meat and a butcher for local shoppers. (Courtesy of Marilyn Parker.)

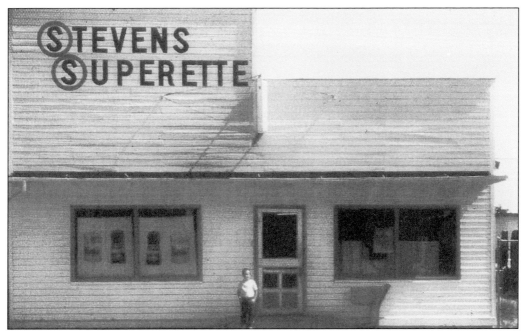

When Rupert Weimer retired in 1966, he sold the property to Ralph Stevens, who operated Stevens Superette until it burned in the 1970s. After the fire, Ralph moved his grocery store to the hill on the corner of Highway 83 and Hilltop Road. Since it was the only grocery store for more than 15 miles, it prospered. (Courtesy of Marilyn Parker.)

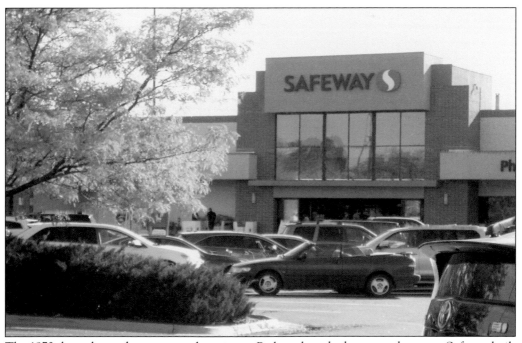

The 1970s brought modern grocery shopping to Parker when the large conglomerate Safeway built a supermarket. Stevens Superette briefly held on against the competition, but the store eventually closed. The building reopened as a hardware store. (Courtesy of Marilyn Parker.)

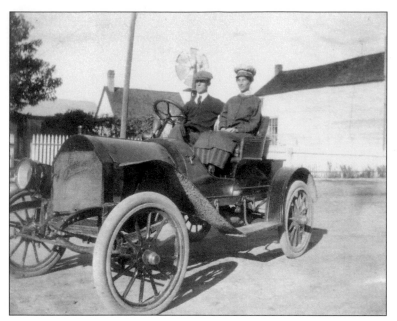

At various times, Parker businesses included blacksmiths, machinery sales, ice cream parlors, and with the arrival of the automobile in town, a garage. The first automobile in town was owned by the Newcombs, pictured here out for a drive. (Courtesy of Marilyn Parker.)

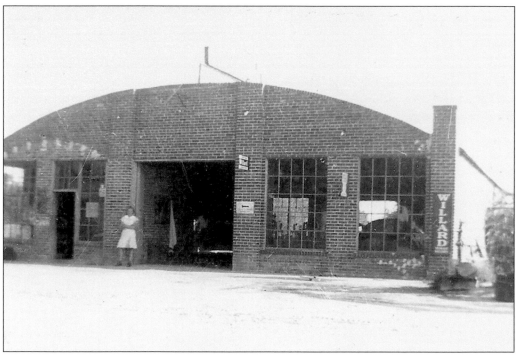

Later, Art Crater established a garage along Mainstreet. He sold cars and serviced them in the garage. Gasoline pumps installed outside the establishment made the business a full-service station. In 1929, the garage burned to the ground. Simeon Flierl purchased the garage in 1929 and ran the business until 1944, when staffing problems caused by World War II made the operation difficult. Flierl sold the property to the Ryan brothers, and later it became a feed store. (Courtesy of Chuck Flierl.)

Young Don Murray established a garage on the other side of the street. Don's Garage provided service for cars in addition to gasoline until the mid-1970s. He offered tires and occasionally offered machinery repair services for local farmers and ranchers. (Courtesy of Marilyn Parker.)

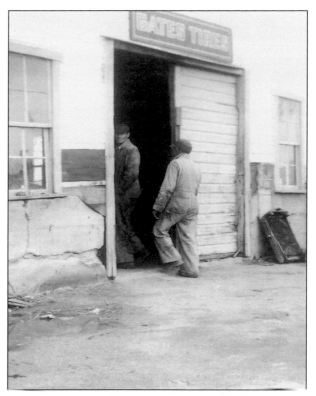

A favorite story of locals concerns a dog Don Murray owned that liked to lie down and go to sleep in the middle of the street. It was especially fond of crawling into a pothole in the gravel street and napping. Residents watched carefully for the dog and made sure to drive around the pooch when it was napping. (Courtesy of Marilyn Parker.)

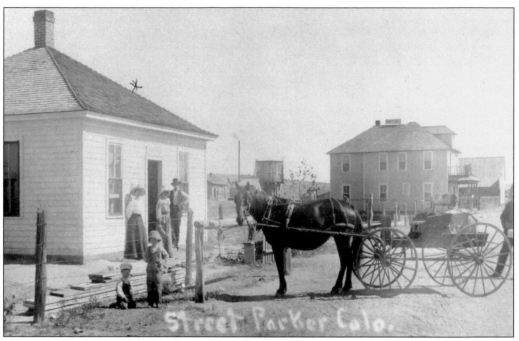

The post office had an easier time staying in business. First in the 20-Mile House, most speculate that the post office was moved into this building, owned by Frank Montgomery, due to the constant traffic at the 20-Mile House. Although James Sample Parker remained as postmaster until 1910, his wife, Mattie, could at least keep her house clean. (Author's collection.)

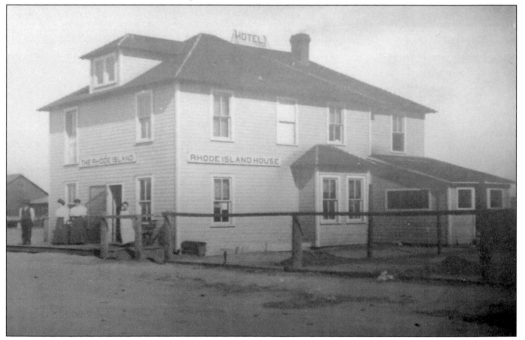

For a time, the post office moved to the Rhode Island Hotel under the tenure of Victoria Newcomb. The hotel was probably a logical move for the growing community, but mail services, particularly the demand for mailboxes, soon outgrew that facility. (Courtesy of Marilyn Parker.)

In 1917, Victoria Newcomb purchased the piece of land formerly occupied by the building housing the barber, meat market, and blacksmith. Landowner Charles Everitt sold the now-bare land, and a new brick building was erected for the Parker Post Office. The building was later used as a telephone office and a residence. (Courtesy of Marilyn Parker.)

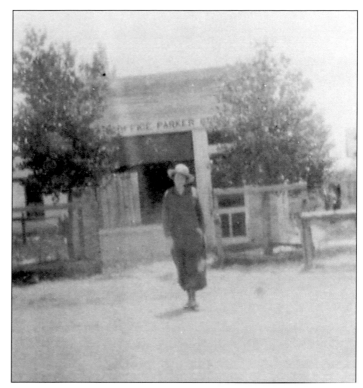

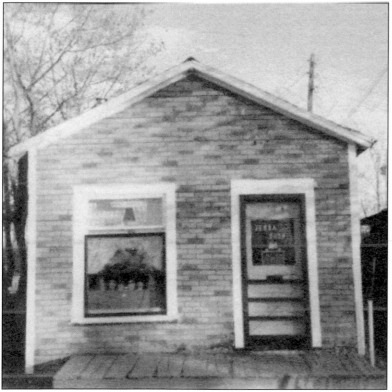

By the 1950s, the post office was located on Pikes Peak Avenue. Victoria Newcomb continued as postmaster with assistance from her sister Laura Claussen. The post office building was close enough to the school that students were frequently allowed to go to there during lunch to retrieve family packages. (Courtesy of Marilyn Parker.)

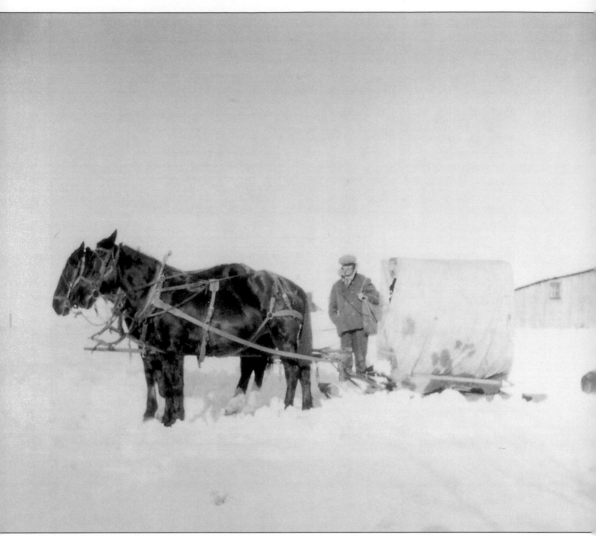

Early in its service, only one rural route carrier delivered the mail to outlying areas around Parker. The first Parker rural mail carrier of record was Douwe Hellinga. Early residents knew they could depend on Hellinga. He delivered a day-old newspaper and groceries on occasion if his customers were unable to get out due to bad weather or illness. (Courtesy of Marilyn Parker.)

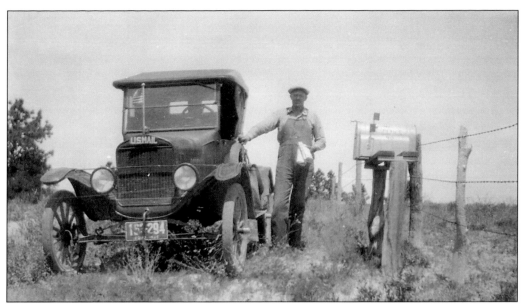

When the weather would not permit Douwe Hellinga to deliver the mail in his Model T, he found another means of covering his rounds. In the particularly bad snowstorm of 1913, Hellinga delivered the mail with the assistance of a horse-drawn sled. (Courtesy of Marilyn Parker.)

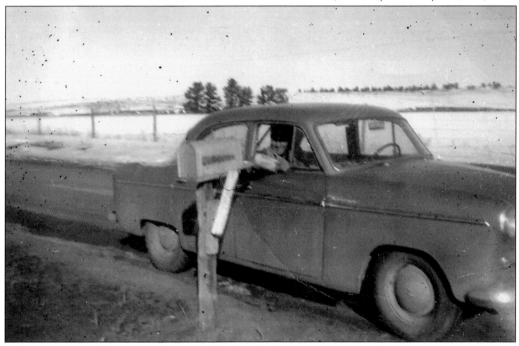

When Douwe Hellinga retired, Joe Rothschopf took the route as a substitute. Young veteran Al Murray took over the rural route after World War II. Murray delivered the mail in the blizzard of 1946, and his expertise as a road grader driver helped him to clear the roads for his job. Traveling the 32 miles around Parker, Murray brought the mail three days a week. Following the path of his predecessor, Murray brought medicines from the drugstore and occasionally necessities from the grocery store. (Courtesy of Marilyn Parker.)

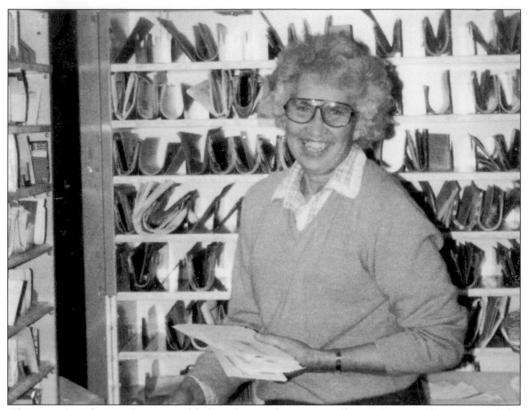

Al Murray's wife, Marilyn, was added to the rural courier staff in 1958 as a substitute, and she became the regular carrier in 1968. Marilyn delivered mail until her retirement in 1988. In addition to the large post office and a satellite station in the Stonegate subdivision, the Parker rural delivery system includes 485 routes and a staff of over 20 carriers and substitutes. (Courtesy of Marilyn Parker.)

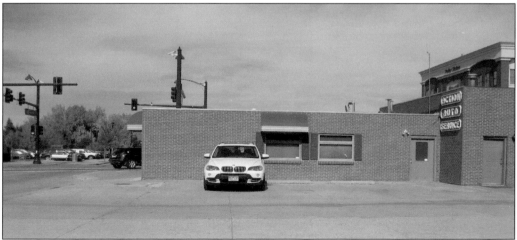

As Parker grew into a bedroom community of Denver, a series of post office buildings were constructed and then abandoned as the service outgrew the accommodations. The first building was a brick structure on the corner of Mainstreet and Pikes Peak Avenue. This building is currently occupied by Action Auto. (Courtesy of Marilyn Parker.)

Parker outgrew the second building off Hilltop Road. The third building was in the same shopping center on Hilltop Road and became known as the solar post office. One of the early commercial buildings with solar heating, the system did not work as promised, and the postal workers took to wearing gloves to sort the mail. (Author's collection.)

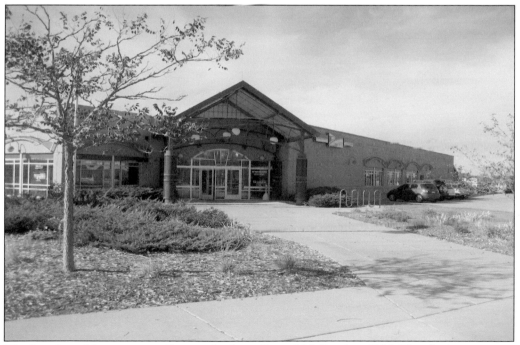

The fourth and largest post office was built on Dransfeldt Road in 2009. This facility seems to be adequate for the large increase in postal customers. (Author's collection.)

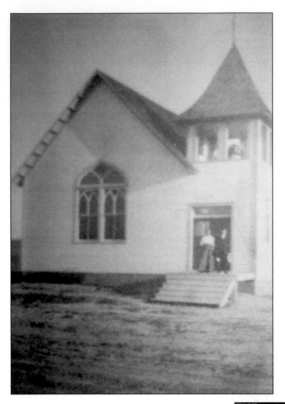

In 1912, Parker's physician and local school superintendent Dr. Walter Heath spearheaded a local group to build a church in Parker. Until that point, Mattie Parker and Mary Foster, Elizabeth Tallman's sister, had used the schoolhouse to hold Sunday school. Sporadically, a circuit rider would conduct church services for adults. With a donation of land from Dr. Heath and monetary donations, plans for a church were under way. (Author's collection.)

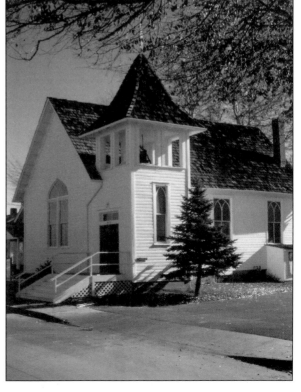

The entire community pulled together to build the Parker Methodist Episcopal Church, later called Ruth Chapel. It really did not matter what religion one practiced before arriving in town, so everyone offered their assistance to build the church. Farmers and ranchers devoted their free time to shingling, putting on siding, and placing windows. The building was completed in 1913, but Heath died before he could see his dream completed. The building is the only one in town in the National Register of Historic Places. (Author's collection.)

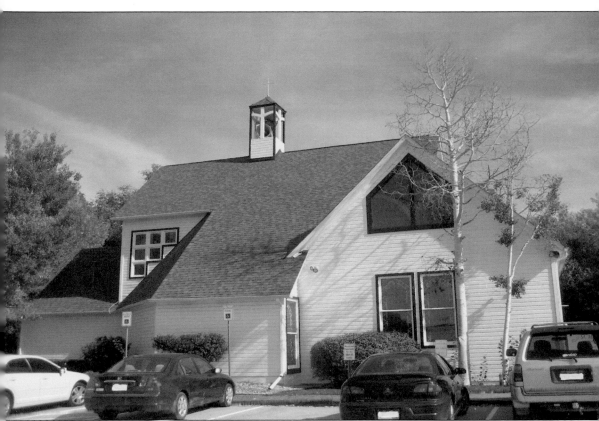

By 1916, the Ava Maria Catholic Church had been completed across the street from the Parker Methodist Episcopal Church. Unlike Ruth Chapel, Ava Maria did not require local volunteers to build it. It held services until the late 1950s. In 1977, Saint Matthews Episcopal Church purchased the Ava Maria building and moved it to their property on Pilgrims Place. (Author's collection.)

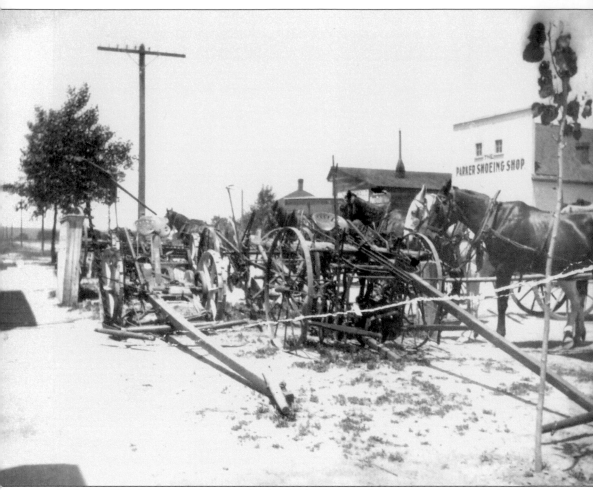

As dictated by the surrounding area, Parker had a farm machinery store to provide the necessary equipment for locals to produce the needed crops. Where irrigation was available along Cherry Creek, new farmers began raising corn and beans. West of town, a cherry orchard watered with a ditch from the creek also appeared. (Courtesy of Marilyn Parker.)

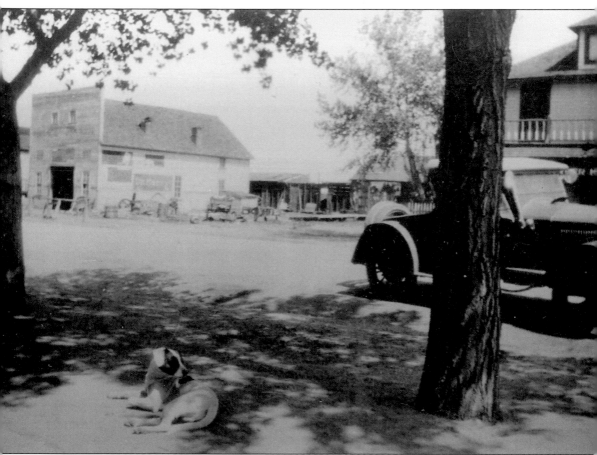

Pictured here is a 1920s Parker street with a full accompaniment of staple businesses. The railroad had performed its purpose—the town would survive. (Courtesy of Marilyn Parker.)

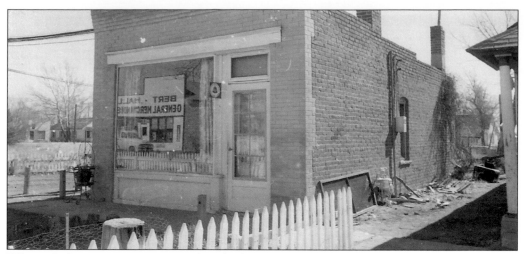

When telephone service came to Parker, the former 1916 post office building became the telephone office. The telephone line was strung along fence posts and connected subscribers with the outside world. (Courtesy of Marilyn Parker.)

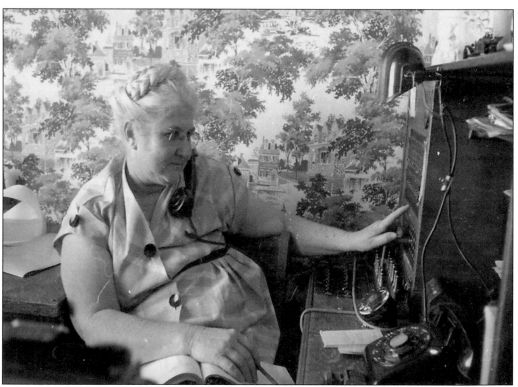

Vivian Huss became the telephone company's central (operator). Huss provided a service beyond connecting neighbors and their loved ones, as she frequently she carried messages of absences from one resident to the other and could also relay to family members a need for groceries or medicines. It was a sad day for many when the rotary dial system replaced Vivian Huss as central. (Courtesy of Marilyn Parker.)

Six

THE COMMUNITY PULLS TOGETHER

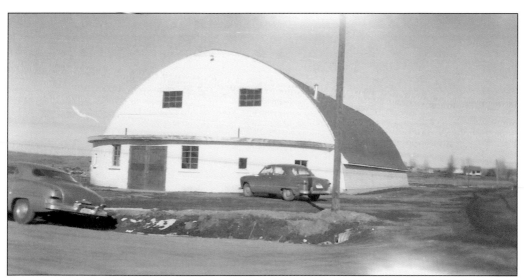

In 1949, the defeat of a bond issue dealt a crushing blow to the Parker community. The basketball team complained of splinters from falling on the aging wooden floor in the old railroad shed. Opponents ridiculed the small town for its lack of modern facilities. Something needed to be done. (Courtesy of Marilyn Parker.)

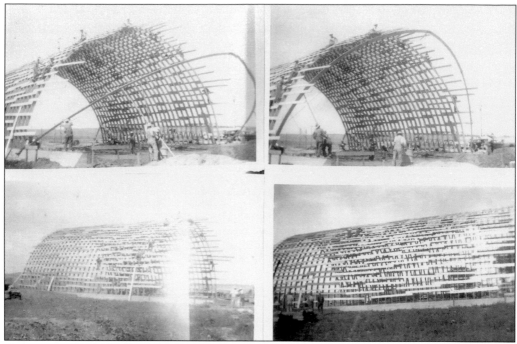

Community leaders gathered to decide what could be done to remedy the situation. Things were difficult for farmers and ranchers, as the area was in the midst of a drought. Money was difficult to spare, but everyone had time and a dream. (Courtesy of Marilyn Parker.)

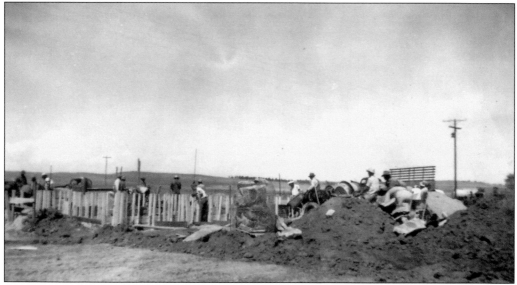

A citizens committee formed, canvassing Parker and the surrounding areas for donations to construct an all-purpose building. Donations ranged from a few dollars to several thousand, and an auction was held to raise additional funds. Charlie O'Brien contributed a piece of land toward the west end of the street, as did the Rosenthals and Lena Poppiourt. (Courtesy of Marilyn Parker, the Anna Rowley collection.)

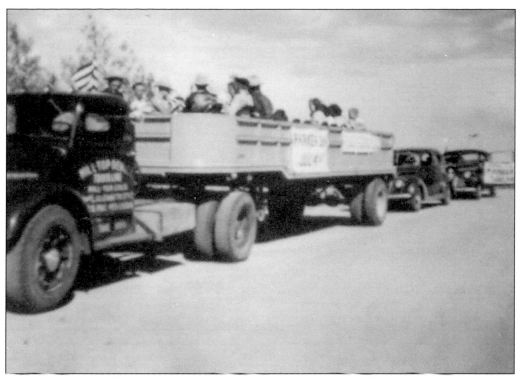

A Denver car dealership contributed a car, which was loaded onto a flatbed trailer for a raffle. In the 1950 Parker Day's parade, the car joined other parade floats, encouraging out-of-town visitors to purchase raffle tickets. Residents traveled around the community and to nearby Denver suburbs to solicit donations from businesses. (Courtesy of Marilyn Parker, the Anna Rowley collection.)

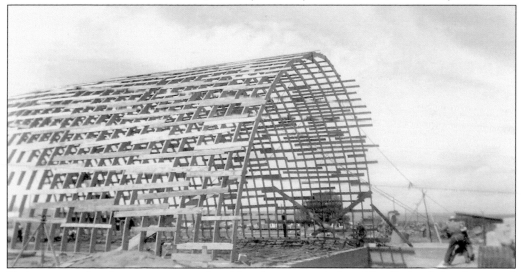

Various types of roof trusses were considered, but the community board finally decided on laminated trusses in a rounded configuration. Lumber was ordered from a company in Oregon, and the wait for the building began. Robert Rowley was named as construction foreman. While waiting for the lumber delivery, the men dug a footer so that the trusses and concrete block base of the building would be solid. (Courtesy of Marilyn Parker, the Anna Rowley collection.)

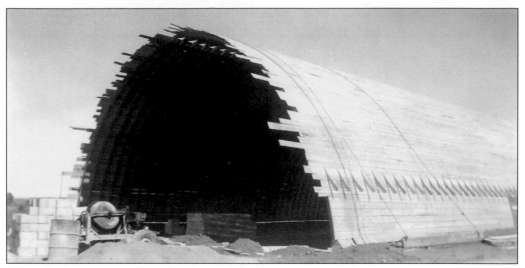

When the lumber arrived, workers hoisted the first trusses into place using manpower and ropes to ease each of the ribs into place. The building was beginning to take form. Farmers and ranchers were having a dry year, so they would feed their animals and then head into Parker to work for the day. (Courtesy of Marilyn Parker, the Anna Rowley collection.)

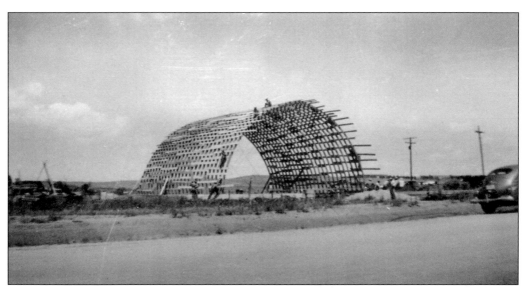

The most difficult task was now at hand. No one felt confident about shimmying up the arches to nail the first boards and tie the trusses together. Two local men, Albert Pearson and Earl Everitt, volunteered. The first trusses were slowly wobbling in the breeze, but the men were able to begin tying the trusses together. (Courtesy of Marilyn Parker, the Anna Rowley collection.)

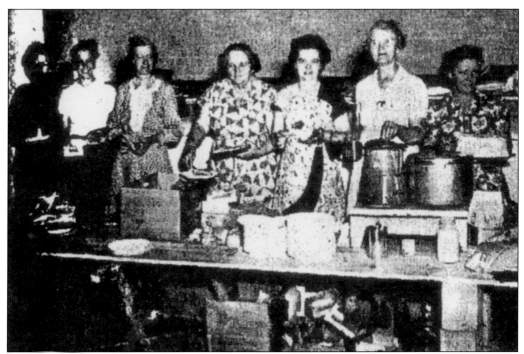

The Parker women were not excluded. The female Home Demonstration Club members organized community women to cook noon meals for the crew. The ladies never knew how many men would be working on a particular day. Chores at home like harvesting wheat and cutting alfalfa still had to be done. The men came as often as possible, but it was a volunteer job. (Courtesy of Marilyn Parker, the Anna Rowley collection.)

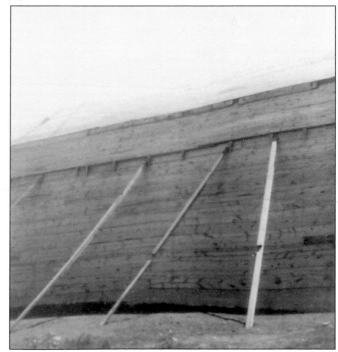

At last, the trusses were tied to each other, and the form of the building took shape. Once the arches stopped swinging, more of the volunteers were willing to climb to the steep top and work on closing in the building and later shingling the roof. (Courtesy of Marilyn Parker, the Anna Rowley collection.)

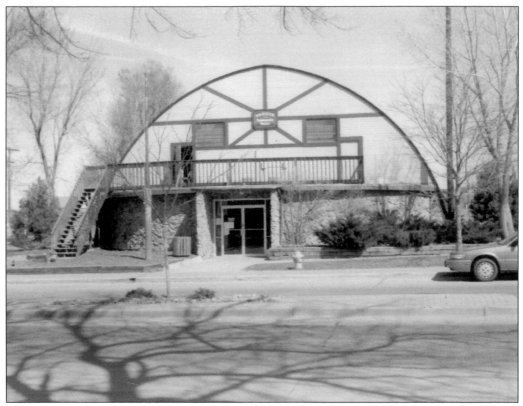

In the final stage, everything but the concrete block foundation was covered with shingles. The short walls were sided and painted white. Now the crew could concentrate on the concrete floor and the hardwood basketball floor above. (Courtesy of Marilyn Parker, the Anna Rowley collection.)

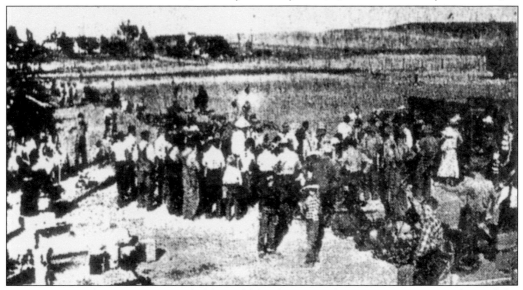

At one point, a large auction was held to add funds to complete construction. Members of the community brought livestock and produce to be auctioned off so the final construction could be finished. (Courtesy of Marilyn Parker, the Anna Rowley collection.)

GRAND
OPENING

Parker Community Hall
Parker, Colorado

SATURDAY NIGHT,
DECEMBER 9TH

1950

Dance - Refreshments - Entertainment - Door Prize

We Especially Extend an Invitation to Those Who have Helped to Make This Building Such a Success

EVERYBODY WELCOME
. . . . EVERYBODY COME!

Admission $1.00 - - - Ladies Free

Posters announced the celebration of the building's completion. A huge dinner, a dance, and a mock wedding provided 1,400 guests with entertainment for the evening. (Courtesy of Marilyn Parker.)

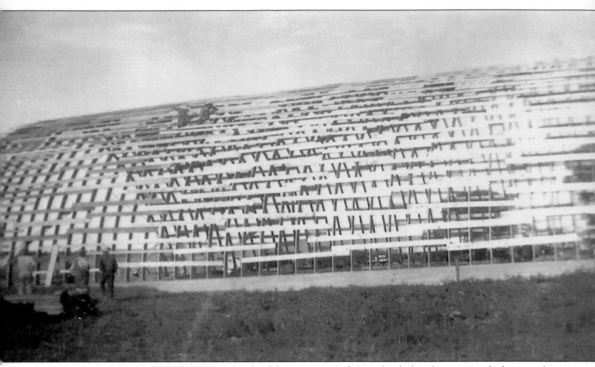

The livestock and produce auction had been successful, as had the donation pledges and car raffle. From beginning to completion, the community had pulled together to build a facility for school extracurricular activities. (Courtesy of Marilyn Parker.)

Seven

PARKER CELEBRATES

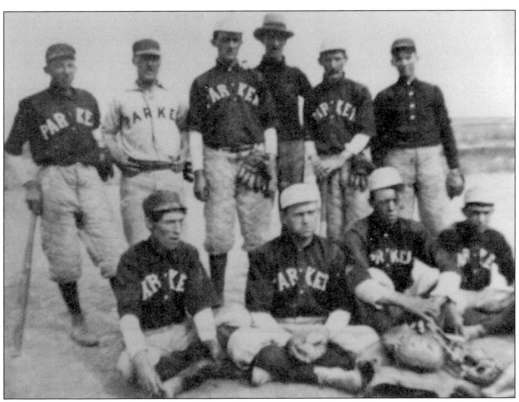

Parker's citizens chose the Fourth of July as the centerpiece of its celebrations. Yearly, the holiday was marked by parades, picnics, and a baseball game between a neighboring town and the Parker town team. The town team players were described by one young resident as "darlings." This set of darlings from the 1900s includes, from left to right, (first row) ? Sweet, ? Childs, Dack Bauldauf, and Edgar Montgomery; (second row) Billy Ellis, Richard Hawkey, Earnest "Bud" Jewell, Charles Montgomery, A. Herzog, and Otis Tillery. (Courtesy of Marilyn Parker.)

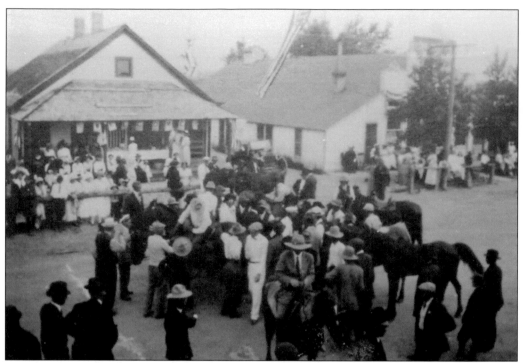

Perhaps the most notable celebration occurred in 1899, when Parker's Mainstreet was the site of the $10,000 horse race. James Sample Parker and general store owner Norman D'Arcy pitted their beloved horses against each other. The *Weekly Mascot*, a local newspaper, is worth quoting: "As they neared the wire a single bullet could have furrowed each horse's brow without drawing blood. The tape is crossed and none were able to tell who had won until the judges announced that D'Arcy's horse by sticking out its tongue had won by a lap." (Author's collection.)

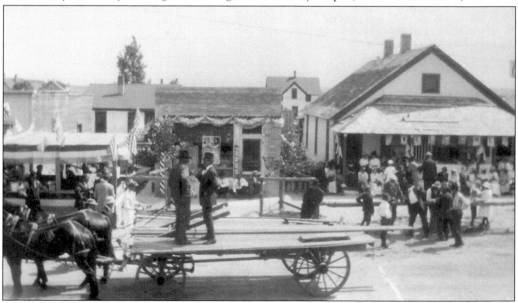

The judges for the race did not have the advantage of a photographic finish, but their perch on the top of the hayrack gave them a great view of the final seconds of the race. (Author's collection.)

Many of the parades in town included music from the Parker Band. Resident James Newcomb formed the band early in his residency and entertained locals at every opportunity. Victoria Newcomb, his wife, also played in her leisure hours away from her postmaster duties. The band is shown here during one of their practices. (Courtesy of Marilyn Parker.)

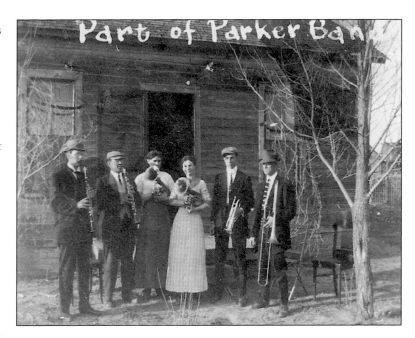

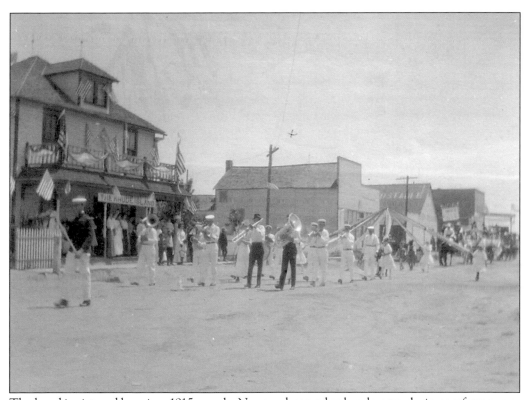

The band is pictured here in a 1915 parade; Newcomb served as bandmaster during performances. At one time, the local newspaper reported the James Newcomb band as a coronet band, but as this photograph attests, other instruments had joined the ranks. (Courtesy of Marilyn Parker.)

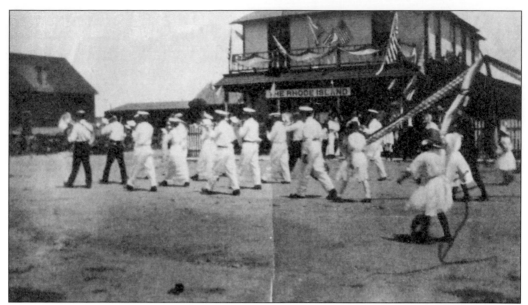

Anna Lewis Rowley, daughter of storekeeper Norman Lewis, marched in this 1916 parade. She is carrying the maypole in this photograph. (Courtesy of Marilyn Parker.)

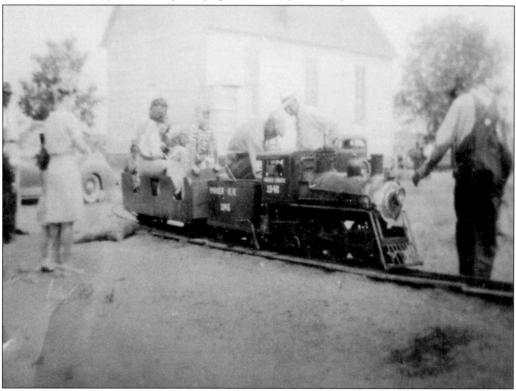

After Doug Ryan moved to town, the parade had an additional attraction. When the parade had passed, Ryan set up his small train and a circular track next to the Catholic church in the open lot across from the schoolhouse. All of the local children rode around the track in the open cars with Doug Ryan, Bob Rowley, or another parent acting as engineer. (Author's collection.)

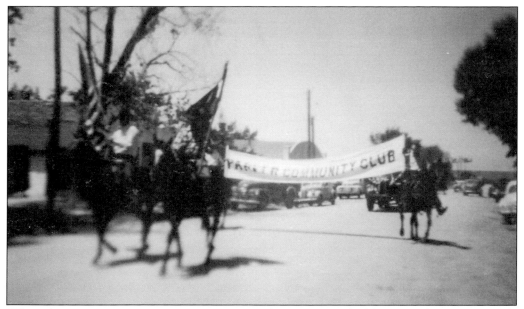

When the town was raising money to construct the community building, a Littleton automobile dealer gave a new Ford to raffle as a fundraiser. The building committee placed the car on a flatbed truck and added it to the parade. The Parker High School Band rode bandbox style to call attention to the car. (Courtesy of Holly Wallden.)

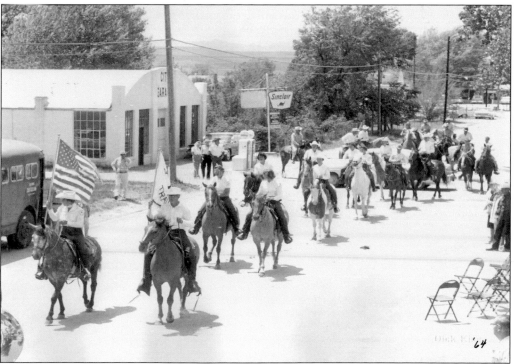

Equestrian entries have always been an important part of the Fourth of July parades. Whether a 4-H horse club or the Parker Trail Riders, horses played an important part in the celebration. (Courtesy of Bob and Josie Fetters.)

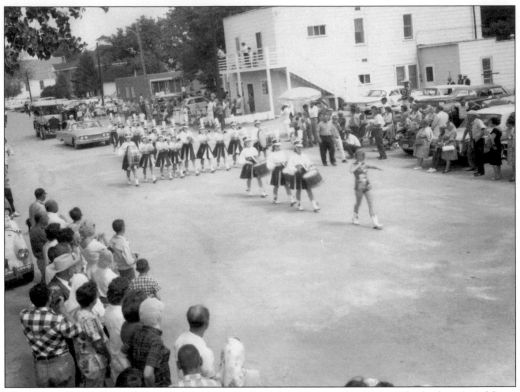

The Parker High School Pep Club joined the festivities to march along with the band and later Scout troops. Occasionally, people commented that there would not be any spectators because everyone was in the parade. (Courtesy of Marilyn Parker.)

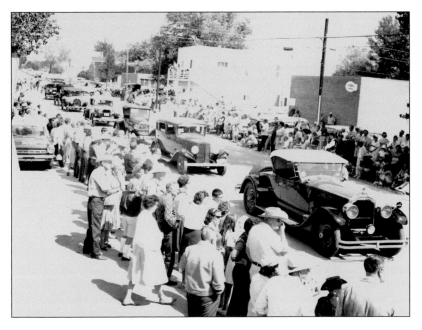

In 1964, Parker celebrated its 100th anniversary with a spectacular parade, which included a parade of classic cars at the head of the other entries. (Courtesy of Marilyn Parker.)

The 1988 parade celebrated Parker's 124th anniversary by honoring Parker pioneers. The 20-mile marker, moved to accommodate the widening of Highway 83, was rededicated in O'Brien Park next to the community building, which housed a two-day museum of antiques and local memorabilia. James Sample Parker's great-granddaughter Betty Naugle is shown here admiring the petrified wood monument after its dedication. (Courtesy of Marilyn Parker.)

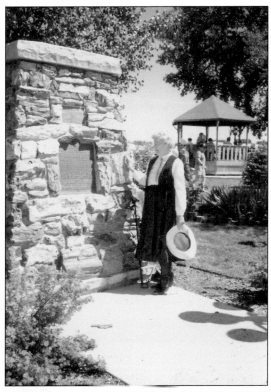

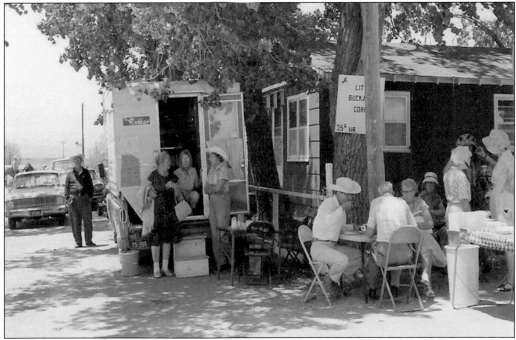

In order to avoid conflicts with other events and towns, Parker Days was shifted to a date in June. Parker still has a parade, but with the growth of the town, a carnival and many food booths have been added to the old-fashioned event. (Courtesy of Bob and Josie Fetters.)

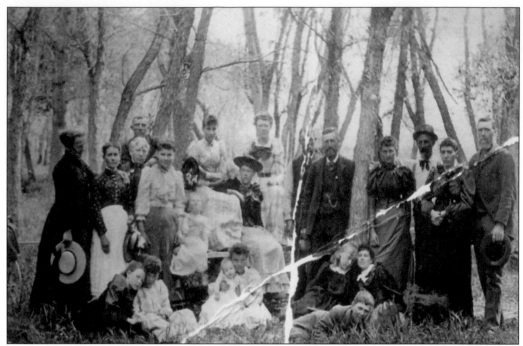

From a lunch after a baseball game to the local Lions Club, Parker residents were always willing to gather for a picnic. The cool banks of Cherry Creek were a welcoming spot for this group in the 1890s. (Courtesy of Bob and Josie Fetters.)

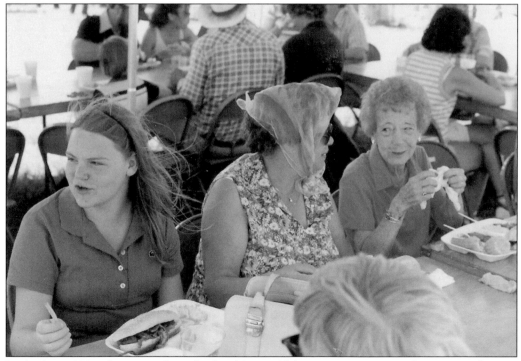

In the late 1980s, this group from the local Lions Club enjoys a picnic nearly a century later at the Fred Dransfeldt home. Picnics are a local favorite. (Courtesy of Bob and Josie Fetters.)

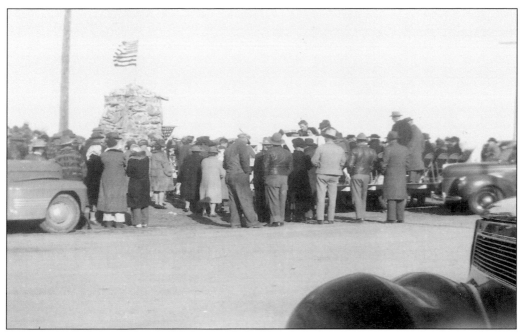

In the 1940s, Parker's schoolchildren gathered local petrified wood, and resident Bels Lyttle built a marker to commemorate the 20-Mile House. In 1946, this group gathered to celebrate the creation of the monument at the corner of Mainstreet and Highway 83. (Courtesy of Bob and Josie Fetters.)

The rededication of the marker in 1988 drew another large crowd. The marker is now correct, as it is one quarter of a mile from the historic stage house. (Author's collection.)

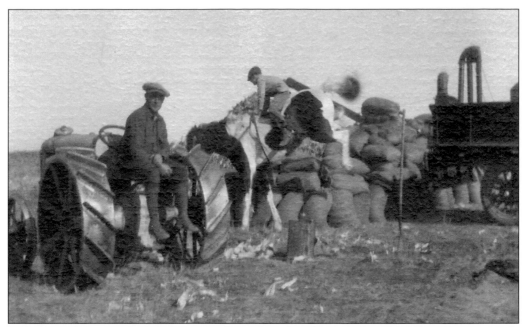

Sometimes the entertainment was not planned, as this photograph of Josie Fetters's great-uncle Chris Kraglund attests. A calm day can turn into an impromptu rodeo. The young cowboy on the horse is not identified. (Courtesy of Bob and Josie Fetters.)

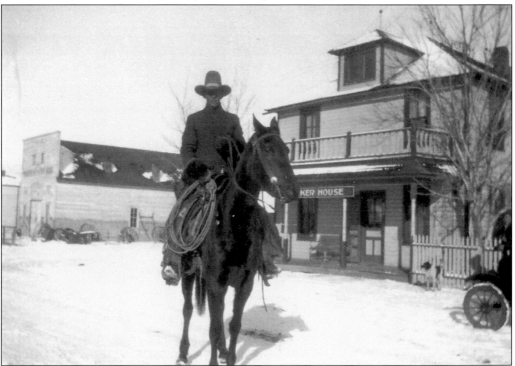

Sometimes in both the past and modern times, a celebration can be as simple as riding one's horse down Mainstreet like this gentleman, speculated to be Richard Hawkey, on an early 1900s day. (Courtesy of Marilyn Parker.)

Eight

1970s SETBACKS, RESURRECTION, AND INCORPORATION

Like many rural communities with similar circumstances, the loss of Parker High School in 1958 deeply affected the town. Residents who had no children in schools found the decades of the 1960s and early 1970s could be filled with entertainment on television. The monthly dances at the community building were the only attraction in town. Local businesses relied on occasional rather than steady business, as automobiles made running to Littleton or Englewood to purchase groceries or large purchases an easy trip. (Courtesy of Marilyn Parker.)

Business buildings were boarded shut, and the small town appeared destined for extinction. But, an interesting dynamic began in Parker's outlying areas. First, a large number of airline pilots and CEOs of large companies began to build large homes with accompanying horse barns. These new residents did not have to show up for a typical day job. If it snowed, no one was screaming that they were fired. Parker's population slowly increased. In 1969, two brothers arrived in town with a big dream. They would level the old abandoned buildings and construct new business buildings. They would build apartments, townhomes, and condominiums. Everything would have the look and feel of the Victorian era, similar to Scottsdale, Arizona. (Author's collection.)

Within a few short months, demolition began at the west end of Mainstreet. Some residents were relieved to find a buyer for their nearly worthless properties. A few buildings were deemed worthy of saving, and the Rhode Island Hotel, Flierl's garage, and the first house on Mainstreet dodged the wrecking ball. (Courtesy of Marilyn Parker.)

For a while, the proposed makeover went well. Landowners sold their property for more than they ever thought it would be worth. Construction began on a new firehouse and a trolley station at the corner of Highway 83 and Mainstreet. Two Victorian-style apartment buildings three stories high dominated the skyline as construction commenced. (Courtesy of Bob and Josie Fetters.)

Then, almost as quickly as it began, construction halted—financing had disappeared. The apartment buildings were left partially finished, empty hulks of crumbling wood frames. (Courtesy of Marilyn Parker.)

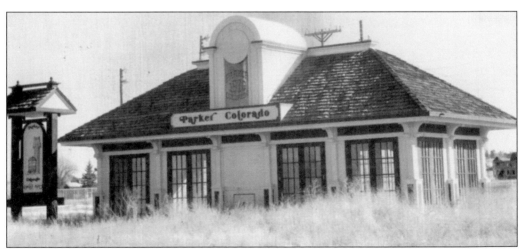

The cute tram station stood empty and devoid of any type of transportation. The firehouse, constructed without in-depth consultation with the volunteer fire department, could not house the fire trucks, as the doors were not large enough. (Courtesy of Marilyn Parker.)

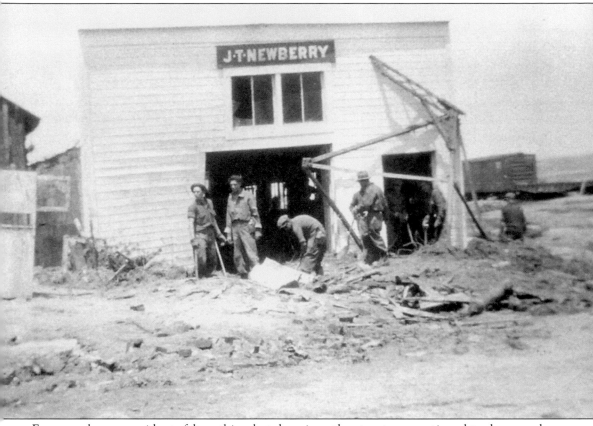

For several years, residents felt nothing but despair as the structures continued to decay and rot. The area was in a construction downturn, and no company was interested in finishing the project. Near the end of the decade, construction rebounded, and several companies purchased the property and abandoned construction with an eye toward salvaging the project. (Courtesy of Marilyn Parker.)

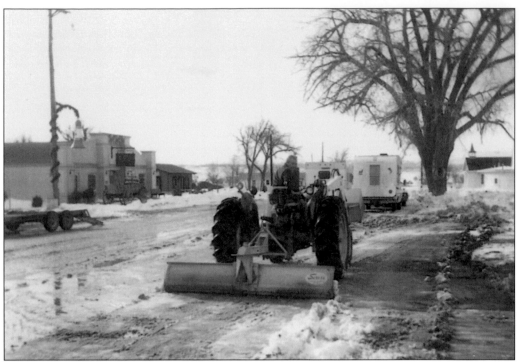

No town government meant streets were covered with snowdrifts in winter unless one of the residents took the initiative to plow the streets after a bad storm. (Courtesy of Marilyn Parker.)

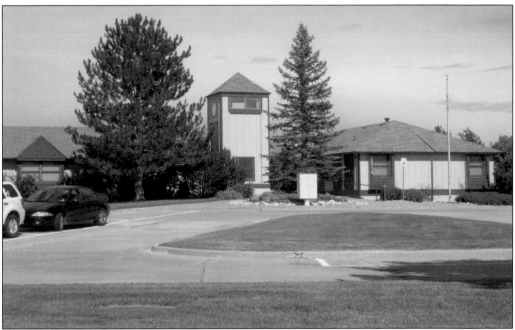

Newer residents did not want the area to have a bad reputation and suggested that Parker become a town. With proper paperwork and an election, Parker became an incorporated town in May 1981. The first city hall seemed a bit overdone, as there did not seem to be enough city workers to fill offices, but that soon changed. (Author's collection.)

With the stability of a mayor, city council, and town administrator, Parker thrived. New businesses were established and succeeded. One mayor, Dean Salisbury, had ideas to make the new town a flourishing place, and his plans worked. Not everyone agreed with Mayor Salisbury, but no one could deny that the town was growing. (Author's collection.)

The town established an infrastructure, which included deep wells, sewage-treatment plants, and modern amenities. One thing no one had planned for was the fast growth. In a little more than two decades, Parker grew from a population of 200 to 20,000. The population of Parker as of this writing is 46,000. (Author's collection.)

The first apartment buildings grew into several apartment complexes and a village of townhomes. One subdivision became 10 subdivisions, with more on the way. (Author's collection.)

The three general stores grew from the friendly mom-and-pop variety into two major grocery chain stores. Major chain restaurants and hardware companies appeared, with smaller stores in the mix. Now the area is home to larger chains like Walmart and Costco, two small bookstores, several jewelry stores, and a plethora of specialty stores. All the retail spaces seem to have adequate customers. (Author's collection.)

Nine

PARKER TODAY

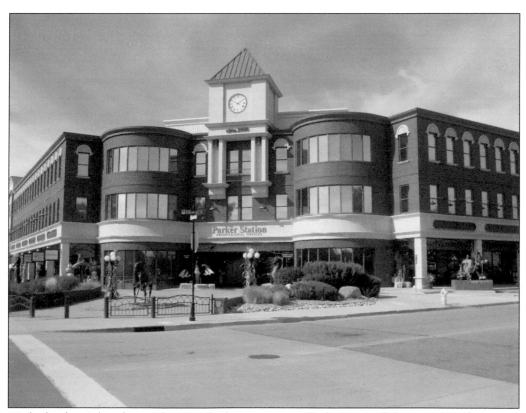

With the foresight of several mayoral administrations, Parker's growth has continued since its incorporation in 1981. A new city hall now houses offices for public works, planning, and other town necessities. (Author's collection.)

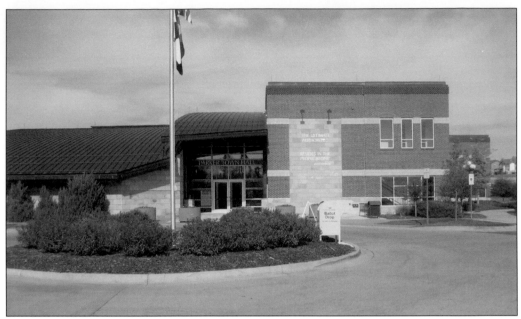

In 2013, the Parker Arts, Culture and Events (PACE) Center was constructed. The center hosts the Parker Symphony and various stage acts, including concerts, plays, and a variety of art shows. It also has several rooms for private events. (Author's collection.)

The town is currently organizing a cultural district along Mainstreet, which will host events not being held in the PACE Center. For several years, the town actively engaged in saving the buildings remaining from the 1970s destruction. (Author's collection.)

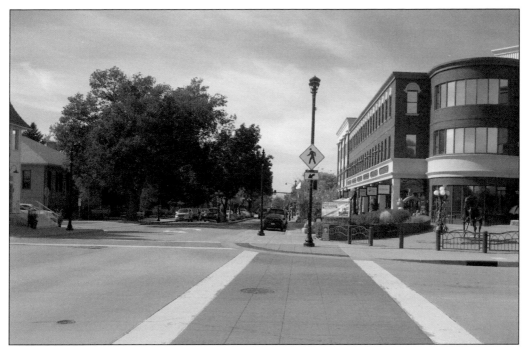

With an eye toward the future, the Parker Water and Sanitation District recently completed the Reuter-Hess Reservoir, a 72,000-acre-foot water containment facility that will satisfy Parker's water needs into the future. (Author's collection.)

One of the first businesses established after the 1970s was a bank. The Bank of the West Board of Directors included local members Fred and Gunhild Dransfeldt. The Dransfeldts encouraged local businesses, which helped the town reestablish itself. (Courtesy of Bob and Josie Fetters.)

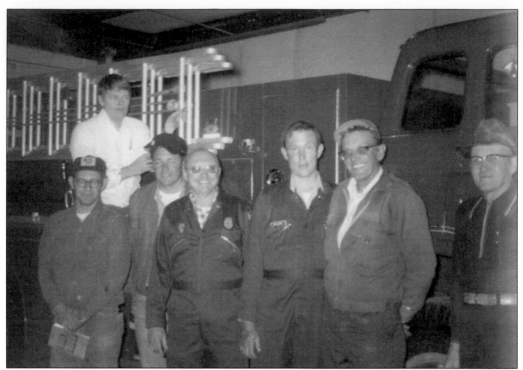

Fred Dransfeldt (far left) had participated in local boards and civic activities. He was a member of the Parker Fire Department Board when it made the initial moves toward modernizing. In 2012, the fire department merged with other suburban departments to become the South Metro Fire Department. No longer a volunteer department, South Metro includes 179 square miles of territory and has over 297 employees. (Courtesy of Bob and Josie Fetters.)

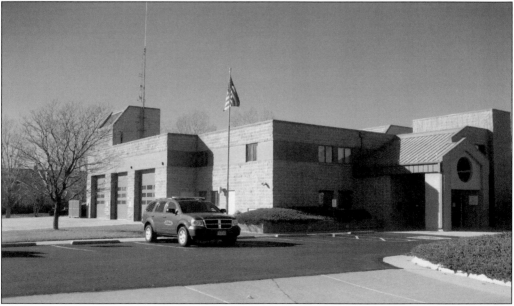

The fire department owns modern equipment, from large engines and tanker trucks to brush-fire equipment and ambulances, to meet their current demands. (Author's collection.)

From the meager beginnings of a few local ladies who wanted new reading material, the Parker Library has grown into a facility that offers children's reading programs, travel events, and other cultural series. The library, currently housed in a large shopping center storefront, is leading a campaign to build a new complex, slated for construction in 2015. Moving and growing with each passing year, the new library will be moving for the fifth time since the 1960s. (Author's collection.)

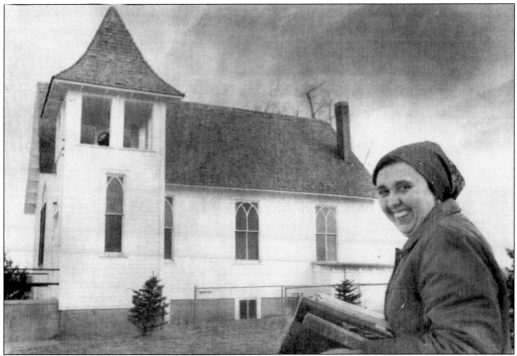

When the library moved from the lower level of the 1915–1916 school to Ruth Chapel in the 1970s, the move was made by hand. People carried the books to the new location. Since that time, each move has been made the same way, with Parker citizens making a human chain. It is unknown if the new move will be made the same way. (Photograph by Joyce Cook, author's collection.)

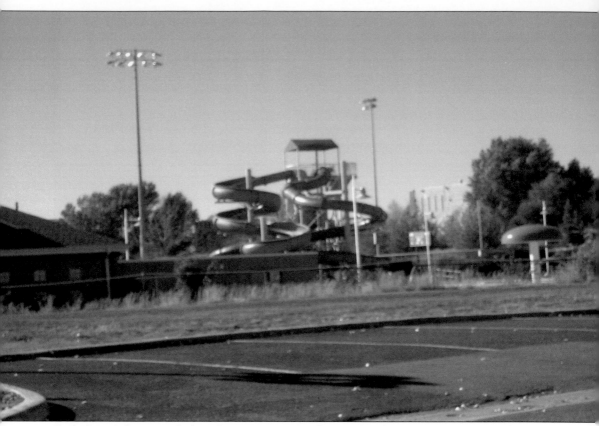

Parker's population includes a large percentage of young families. To accommodate this faction, Parker developed a vital recreation department, which includes a field house, water park, recreation center, a series of athletic fields, and miles of walking and biking trails. On any given weekend, families are involved in a wide variety of activities, from youth soccer games to art classes, at the Mainstreet Center (the former school). (Author's collection.)

Ten

PARKER FOOTNOTES

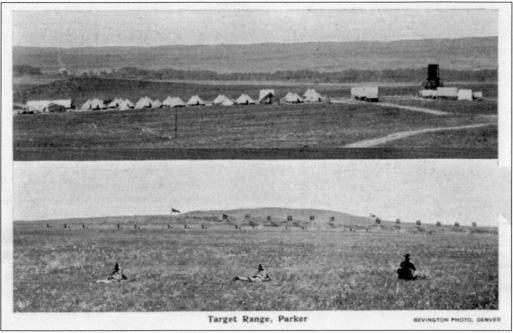

Target Range, Parker BEVINGTON PHOTO, DENVER

From the railroad to the US Army, many additions to the area surrounding Parker have kept the economy thriving. During the early stages of World War II, the Army decided to purchase land for a rifle range. The range west of Parker brought people to the area. In the mid-1940s, the area had an added boost when a bombing range was established northeast of Parker. The soldiers were allowed to attend dances at the community building on weekends, adding new clientele to local restaurants and additional revenue for the community club hosting the dances. (Courtesy of Marilyn Parker.)

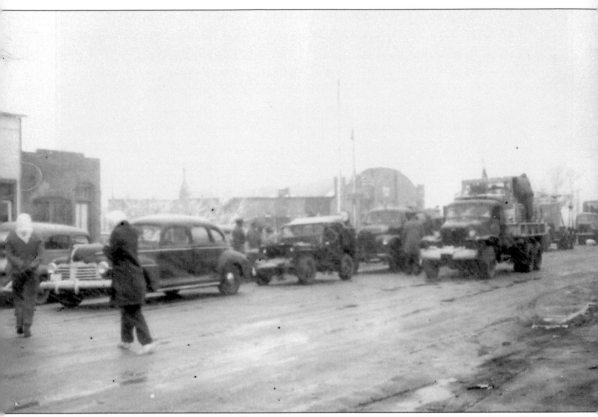

The bombing range contributed additional but odd entertainment. Since the bomber pilots were still in training, a few of the rookies flew too low and ended up in ranchers' pastures and farmers' fields. The impromptu parade shown here is a group of soldiers moving a crashed airplane through town. (Courtesy of Marilyn Parker.)

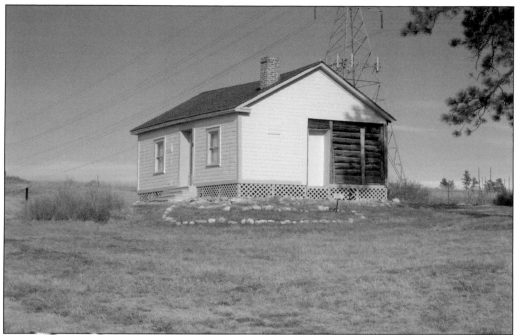

Recent town administrations have attempted to reverse the blows dealt by the 1970s destruction. The Parker Landmarks Commission was formed to identify and preserve historical sites and older homes. One of the first buildings landmarked was the cabin built by John Tallman in 1864 to welcome his bride, Elizabeth. (Author's collection.)

The home of Dora Heath, wife of one of the first full-time physicians, superintendent of schools, and the benefactor responsible for the construction of the Ruth Chapel, was landmarked. When Dora's husband died in 1912, she moved from a larger home on Pikes Peak Drive to this home with her two small sons. (Author's collection.)

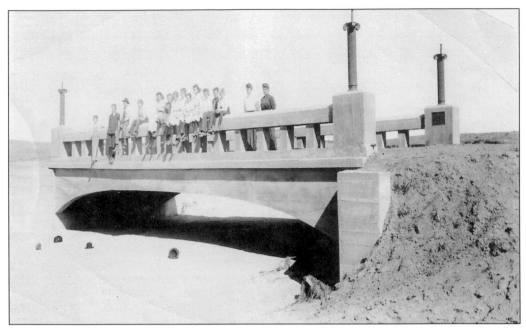

The 1912 concrete bridge site, shown here with the entire student population of James Sample Parker School, was marked despite the fact the bridge washed away in the 1913 summer flood, which also took out the railroad tracks. (Author's collection.)

The Lewis-Herzog house was landmarked to honor the contributions made by mercantile store owner William Lewis to the Parker area. Herzogs lived in the home later. In more modern times, the home was owned by Strafford Tallman, Elizabeth Tallman's son, and his wife, Esther. (Courtesy of Marilyn Parker.)

The Fredrick Hood house was slated for destruction when the Parker Landmarks Commission intervened and saved the remaining structure, moving it to Preservation Park, north of Parker's Mainstreet. Hood moved to Parker in 1911 and purchased the home from Dr. Walter Heath. Fredrick Hood was a stockholder in the Parker State Bank as well as manager and cashier. One story relates that Hood rode throughout the Cherry Creek Valley, gathering financial support for the bank. (Courtesy of Marilyn Parker.)

The Newcomb home was another house preserved by the Landmarks Commission. Built by James and Victoria Newcomb, who rarely resided there, the house originally faced south. No one is sure when the structure was moved one-quarter turn on its foundation. (Courtesy of Marilyn Parker.)

O'Brien's home was a boardinghouse for several years. Jean Martin, who lived with her aunt for some years, remembers many of the boarders who lived in the house. (Courtesy of Marilyn Parker.)

The rear view of O'Brien's was quite unusual, as it had a tall well house that concealed the pump, and many years after Parker was on city water, the well house remained. It was a unique part of Parker. The house was torn down to make room for a large retail and office building, which encompasses most of the block. (Courtesy of Marilyn Parker.)

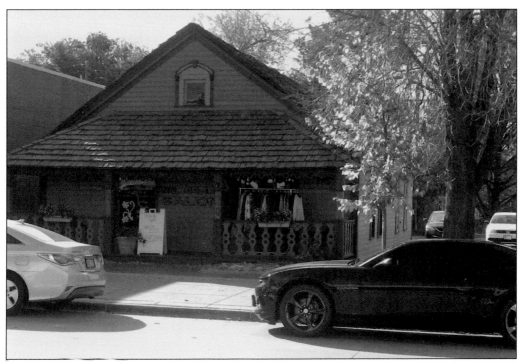

Landmarking is a voluntary process for Parker building owners; some choose not to be involved in the process. The owner of the oldest house along Mainstreet has chosen not to landmark his property, so fears about losing older buildings remain. (Author's collection.)

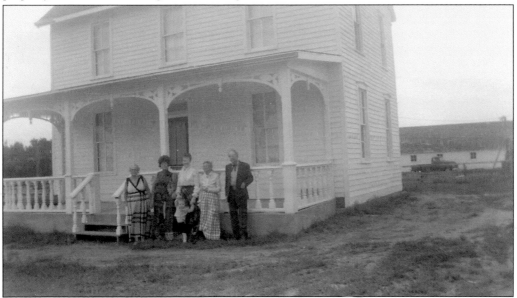

In the 1980s, awareness of historical sites and buildings became a local concern. The Ponce de Leon Chalybeate Springs's two houses were eyed with concern. One of the houses was being used as a barn, and the other remained empty; both structures were beginning to deteriorate. With the cooperation of the owner, plans were made to refurbish the houses, and an open house was held. (Courtesy of Bob and Josie Fetters.)

Eventually, the house was moved by Jensine Kraglund (far left) to her property north of the original site and preserved as an example of the 1800s construction. For a time, it was used as a retail space. Kraglund filled the house with antiques from the period and enjoyed calling it her dollhouse. (Courtesy of Bob and Josie Fetters.)

The second house still sits on the original site. In recent years, plans were made to reunite the twin houses, but the houses remain separated as of this writing. (Courtesy of Bob and Josie Fetters.)

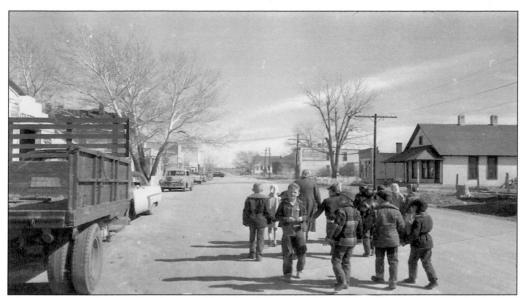

The area around Parker has changed from the dirt roads and mud during a rainy summer to paved streets and modern conveniences. (Author's collection.)

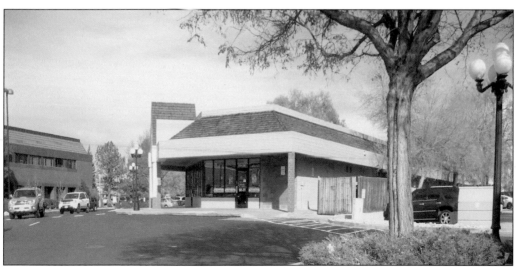

Businesses have changed from creameries and meat markets to upscale restaurants and clothing boutiques. But, the friendly atmosphere remains, just as it was 100 years ago. (Author's collection.)

Parker has always had water problems; either too much water or not enough has plagued the area. The photographs on pages 28 and 29 show the devastation caused by the floods of 1912 and 1913. Whether roads, railroad tracks, or bridges, floodwaters always seemed to deal crushing blows. (Photograph by Charles Hinke, author's collection.)

In 1933, a heavy rainstorm broke the Castlewood Dam upstream from Parker, resulting in a heavy loss of livestock and crops. The dam would never be rebuilt. (Photograph by Charles Hinke, author's collection.)

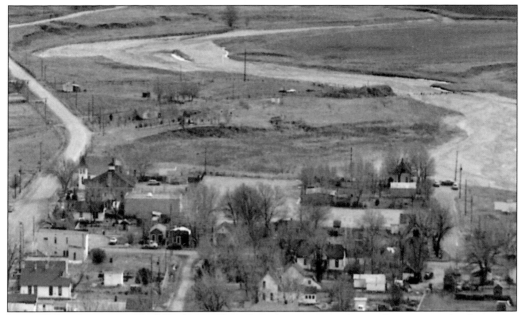

In 1965, heavy rain covered Highway 83 with water in some places. Once again, bridges were washed out, and the city of Denver narrowly missed flood devastation when the Cherry Creek Dam downstream from Parker caught the majority of the water. The floodgates had to be opened for several days to prevent the earthen dam from collapsing. (Courtesy of Marilyn Parker.)

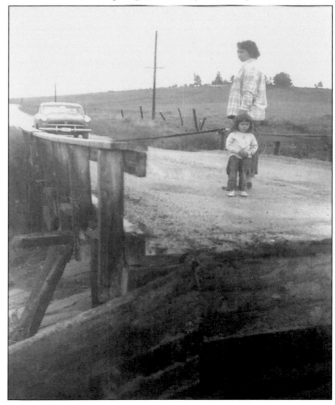

Even lesser rains have brought destruction to the area when gulches overflowed and smaller bridges were taken out. Pictured here are Marilyn Parker and her daughter Rhonda surveying flood damage. (Courtesy of Marilyn Parker.)

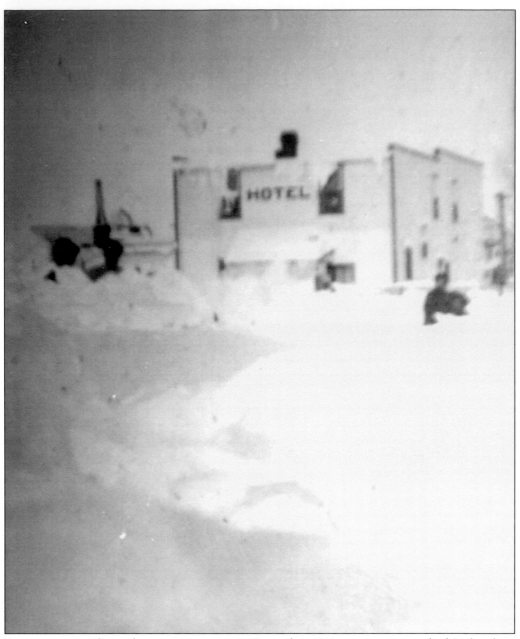

Snowstorms can be as destructive as rain. In December 1913, a snowstorm pelted Parker for a total of six days. The town was without electricity for several more days. No snowplows were available, so residents formed shoveling teams and cleared the approximately six feet of snow. (Courtesy of Marilyn Parker.)

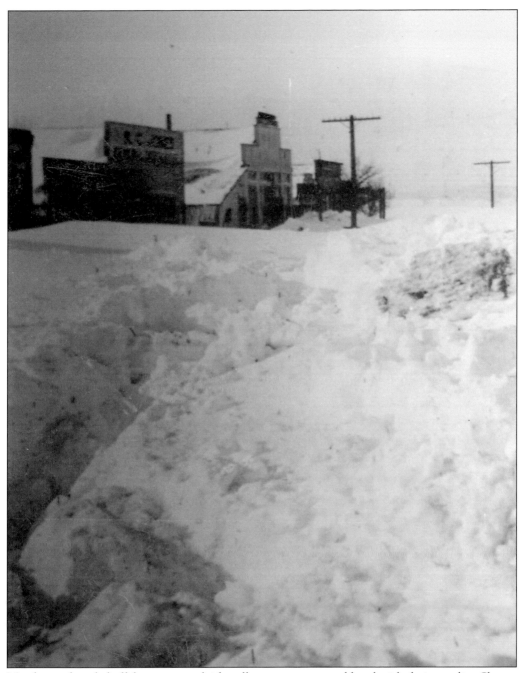

Merchants shoveled off the streets and sidewalks so customers could replenish their supplies. Shown here is a huge drift, with the grocery stores in the background. (Courtesy of Marilyn Parker.)

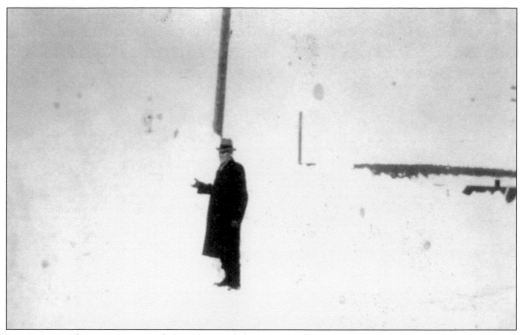

In 1946, another major storm hit Parker and the surrounding area. This photograph shows Janette Everitt's father, Rev. Frank March, standing between drifts east of town. Once again, residents were stranded for several days. The county had finally managed to free residents when a second blizzard followed the first one and buried them again. (Author's collection.)

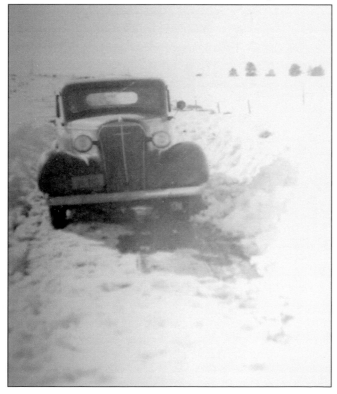

This photograph of a farm truck is another example of the depth of snow from the 1946 storm. In modern times, heavy snowstorms and blizzards have returned to the area, but with modern equipment, most storms have not brought the town to a standstill. (Author's collection.)

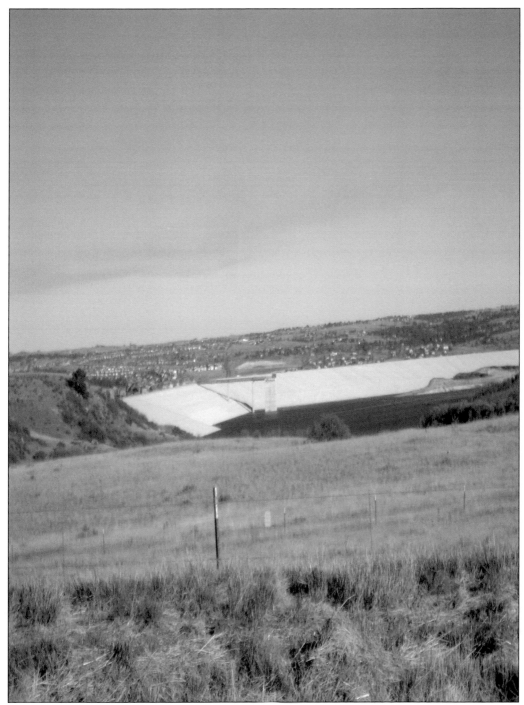

After over a century, Parker has found a possible solution to its water problems. In 2013, the large Rueter-Hess earthen dam that was started in 2004 was completed. The dam will provide water for the Parker area as well as for nearby Castle Rock and several other municipalities. The feast and famine of water should be satisfied into the next century. (Author's collection.)

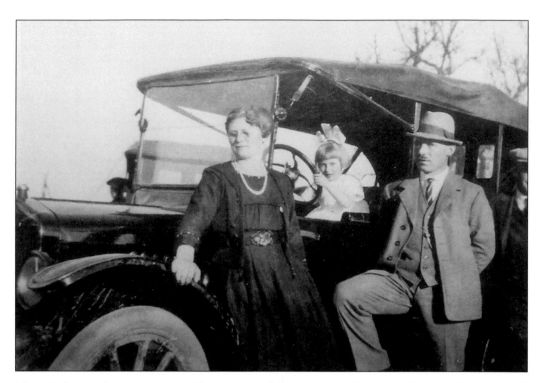

Many Parker residents came, settled for a time, and then moved on, but some who came homesteaded and stayed. The Kraglund and Dransfelt families are two of those who stayed. From their arrival in the Cherry Creek Valley and the Parker area, the Danish immigrant Kraglund family lived in a series of houses owned by Ed and Lena Poppiourt. At one point, the Kraglunds lived in the 20-Mile House. Above, young Gunhild is driving the car with her parent's supervision. Later, she married Fred Dransfeldt, another resident of the area. They are shown below with their daughter JoAnn. (Both courtesy of Gunhild Dransfeldt.)

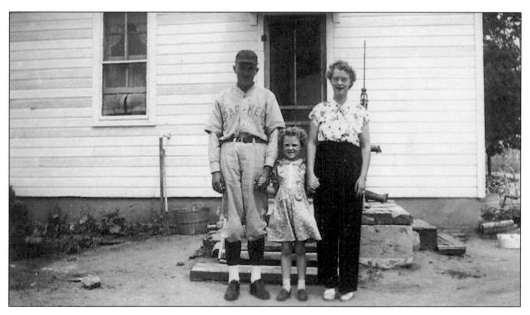

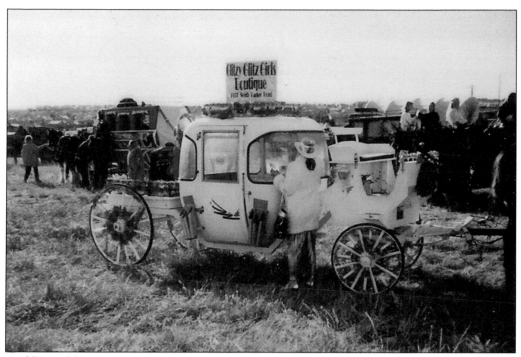

Fred Dransfeldt was an active member of the community and a key player in establishing Parker's Bank of the West. His daughter JoAnn "Josie" and her husband, Bob, have become active in the community. Josie participates in the Parker Days parades with her Glitzy Girls carriage. (Courtesy of Bob and Josie Fetters.)

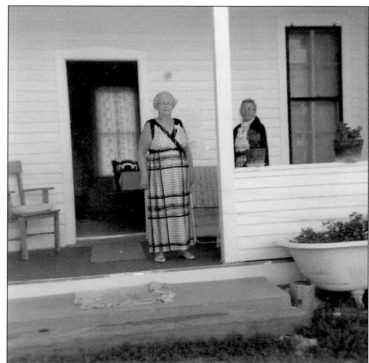

Josie Dransfeldt Fetters was instrumental in the preservation of the Ponce de Leon Chalybeate Springs houses. She is shown on the right here at an open house, and her grandmother Jensine Kraglund is on the left. (Courtesy of Bob and Josie Fetters.)

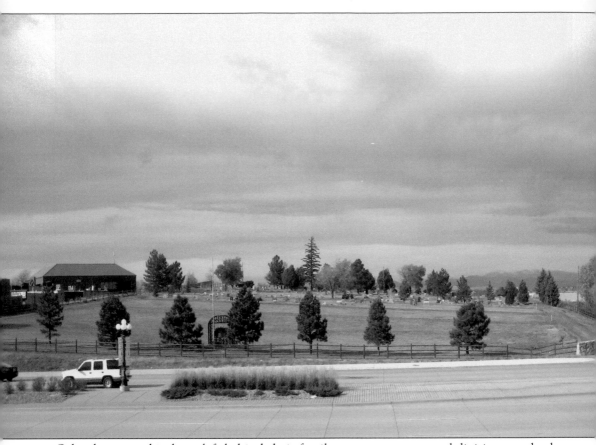

Other homesteaders have left behind their family names on streets, subdivisions, and other localities. One example of this is the James Sample Parker Cemetery. When James Sample Parker's wife, Mattie, died, he gave a plot of land overlooking the 20-Mile House to begin a cemetery. Until that time, the cemetery was about a mile north of Parker. Locals moved the graves from that location, and the Parker Cemetery was started. (Author's collection.)

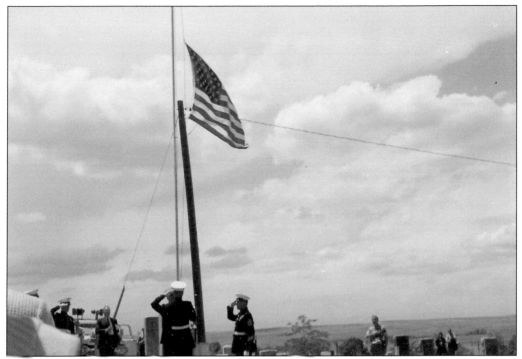

The cemetery has undergone several changes, including the dedication of a new flag area during the 1964 Parker centennial celebration. (Courtesy of Bob and Josie Fetters.)

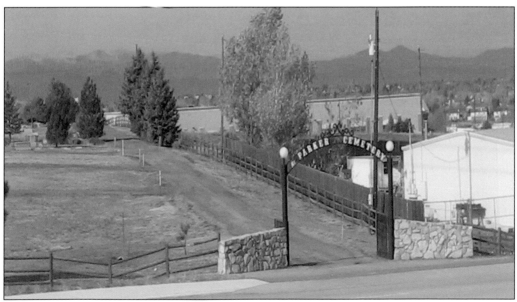

It also received the addition of new gates in 1988. (Courtesy of Bob and Josie Fetters.)

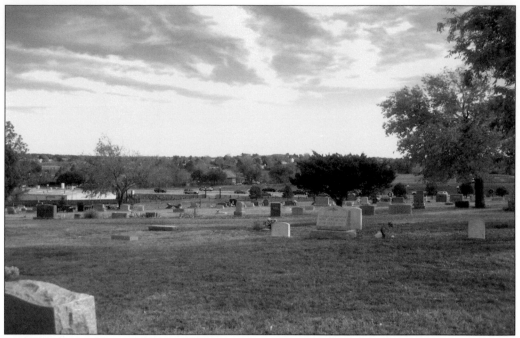

The cemetery is maintained by a private board and has its own water supply. Descendants of those buried in the cemetery maintain the graves and gather once a year for a clean-up day. (Author's collection.)

Every Memorial Day, either local Boy Scout troops or the local veterans' association members place flags on the graves of fallen soldiers, including James and George Parker for their service in the Civil War. (Author's collection.)

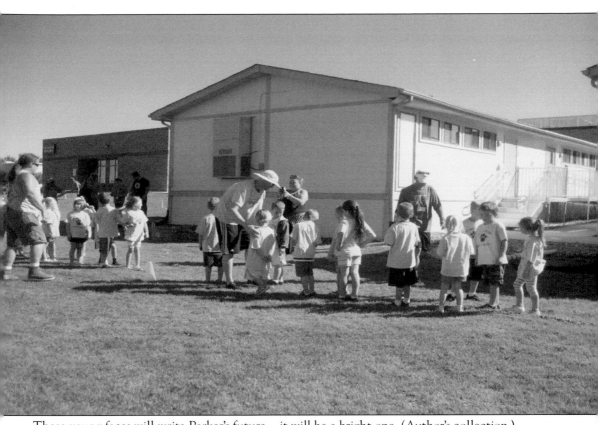

These young faces will write Parker's future—it will be a bright one. (Author's collection.)

From a town that without a railroad would have died in the 1880s to a town that nearly died in the 1970s, Parker has become a vibrant and thriving community. As the adage says, "What does not kill you makes you stronger." (Author's collection.)

INDEX

DISCOVER THOUSANDS OF LOCAL HISTORY BOOKS FEATURING MILLIONS OF VINTAGE IMAGES

Arcadia Publishing, the leading local history publisher in the United States, is committed to making history accessible and meaningful through publishing books that celebrate and preserve the heritage of America's people and places.

Find more books like this at
www.arcadiapublishing.com

Search for your hometown history, your old stomping grounds, and even your favorite sports team.